September 2013, Issue #48

Interview with Frank Bernarducci

Stephen Wright and Eric Zener
The Artists behind the artwork for the film *The Time Being*

Contributors
Tran Nguyen
Patricia Schappler
Gregory Lawless
Eric Burke
Roberto Garcia
Nikki

Special Supplemental Feature

Saturday Night!

Pauline Aubey
Edward Nudelman
Diego Quiros
Lacey Lewis
Deborah Sherman
Richard J. Frost
Michael Montlack
Grace Cavalieri

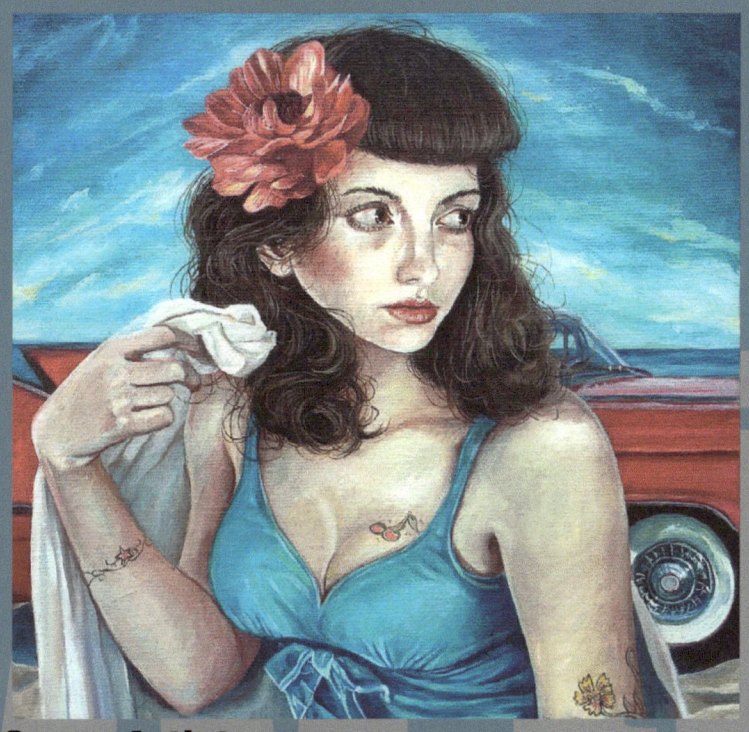

Cover Artist
Brianna Angelakis

Poetry Editors
Michelle McEwen
Timothy Brainard
Helen Vitoria
Cheryl Townsend

GOSS183 Publication
Didi Menendez, Publisher, E.I.C., Designer, Art Director

www.poetsandartists.com

All 4 Volumes Now Available for the Kindle!

The Perspiration Principles

You Get What You Work For, Not What You Wish For.

Howard A. Tullman serves as Chairman of Tribeca Flashpoint Media Arts Academy. He is the former President of Kendall College in Chicago and the former Chairman/CEO of Experiencia, Inc. Mr. Tullman is the General Managing Partner for the Chicago High Tech Investors, LLC and for G2T3V, LLC. He is also the Chairman of the Endowment Committee of Anshe Emet Synagogue, a member of Mayor Emanuel's ChicagoNEXT and newly-formed Cultural Council, a member of Governor Quinn's Illinois Innovation Council and Illinois Arts Council, a member of President Preckwinkle's New Media Council, an Advisory Board member of HighTower Associates, Immerman Angels and uBID.COM and an Adjunct Professor at Northwestern's Kellogg School as well as a regular guest lecturer at the Northwestern University School of Law. Mr. Tullman also serves as a Director of Snapsheet, VEHCON and PackBack Books and served as a long-time Director and Board Chairman of The Cobalt Group, a Trustee of the Museum of Contemporary Art in Chicago and of the New York Academy of Art and the Mary and Leigh Block Museum of Art at Northwestern University, vod as the lead Director (and briefly Chairman) of *The Princeton Review*.

Find out more at www.tullman.com.

Stephen Wright

Both you and Eric Zener have work appearing in "The Time Being" a Tribeca Film directed and written by Nenad Cicin-Sain. Tell us about the movie and how you became involved with it.

I was contacted thru Gallery Henoch in NY. They told me they had a friend who's a very talented movie maker, and was looking for a couple artists to work with him on a new project. I met Nenad at his place in Venice and he gave me the overview of the movie, and the type of the art he needed for it. I thought it sounded interesting since it was about artists, so I accepted.

I immediately recognized your work when I was watching the trailer and became very excited to see it shown in the trailer. However there were a few artworks at the start of the trailer which I did not recognize and later found out that it was your work. Did you have to step away from your comfort zone to work on those pieces?

Well, if you're talking about the fruit images, Eric can tell you about his experience with those.

Where I stepped out of my comfort zone was in making the paintings needed specific for the story. It felt a little like I was making props; they weren't personal to me. The "Nest" painting - the portrait of Frank Langella as Warner was especially difficult. I had to superimpose his portrait over one of Eric's paintings of bramble. I thought there was no way I was going to get the detail in time that Eric had acheived. Also, marrying the different light sources, so it looked like Frank was actually there with the bramble, was a challenge. I finally just accepted my

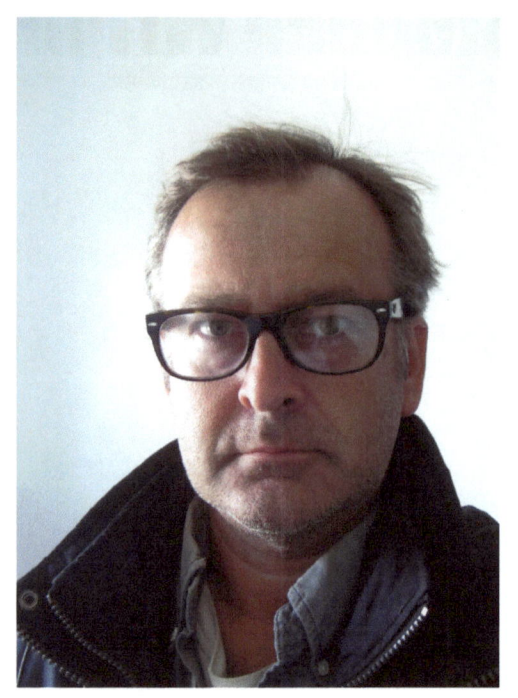

"Currently I'm questioning painting, questioning art, questioning the nature of reality. Are there really infinite universes with infinite me's, making the same mistakes, only doing them just a little differently? I am currently reading too many Philip K. Dick novels (is Richard Nixon really still alive and the Anti-christ?) For some reason these questions have become important since I turned 50.

Also; what is good art? Is it even PC to call something great art anymore? Why are there so many paintings of naked ladies?"

painting was going to be looser (on camera you really can't tell). I wound up painting imaginary branches around Frank's body, so there could be some overlap & shadow interaction and stuff, to make it look like he was really in there. Afterwards I was really happy with the piece.

The other work out of my comfort zone was the painting of Sarah and her daughter. They wanted four intermediate stage paintings, plus the final piece. Making them look like one continuous painting being made was a challenge.

How much of a time-frame did you have to work on the artwork selected for the movie?

Just a few weeks. They kept coming back asking for more pieces! In the end some of them weren't in the film, which is just fine cause I think they were subpar due to time crunch.

Does your own career as an artist relate to any of the main characters in the movie (the painter and the collector) or any of the other roles in the movie?

The director made the movie because I'm sure he related to Wes Bentley's character. I'm guessing Eric identifies with him too; they both have families. I'm single, never had kids, so I related more to the tragic Warner character, only feeling real when he paints.

What are your personal views on the current art scene?

I don't really know much about the current art scene. It looks like there's more than one.

What are you working on next?

Trying to get my FJ60 Landcruiser smogged so I don't have to ride the bus. Oh, and making some small paintings that make me happy.

Nest painting by Stephen Wright for Tribeca Films, *The Time Being*.

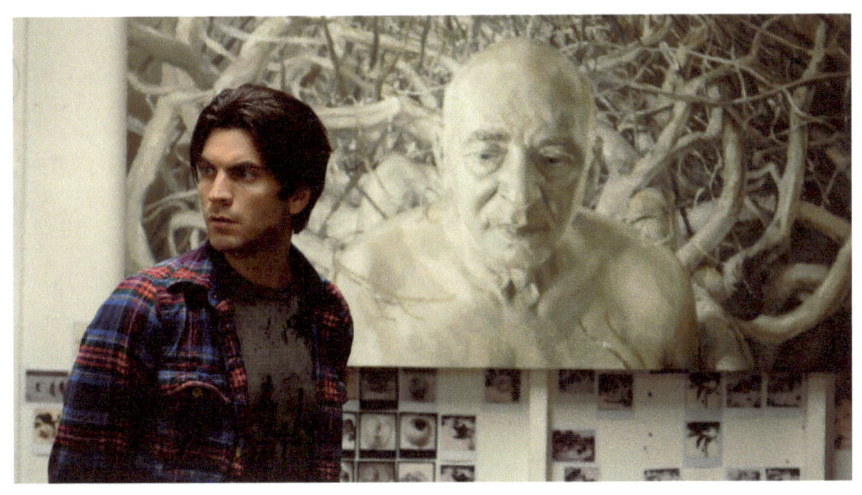

Actor Wes Bentley on the set of *The Time Being*.

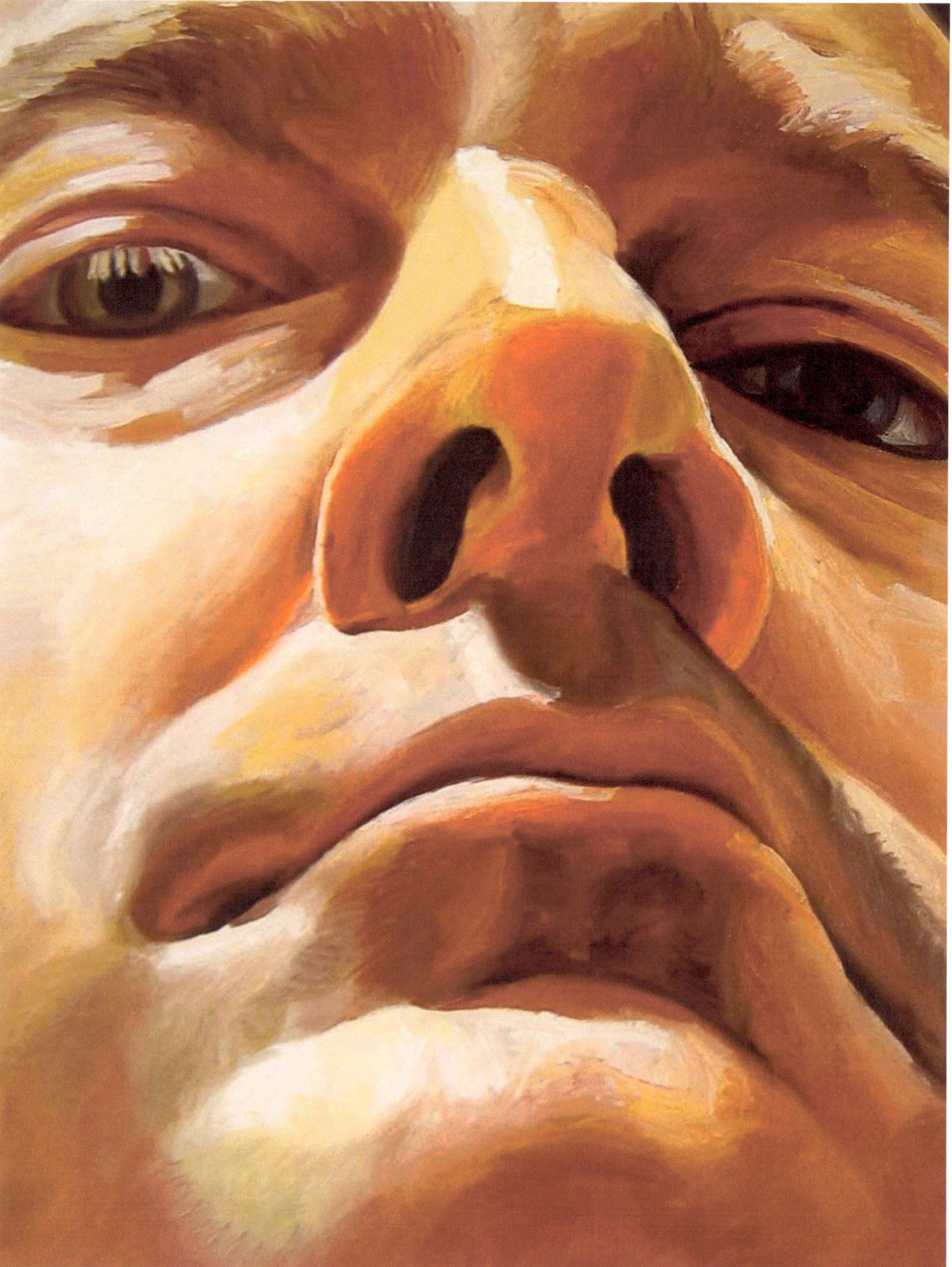

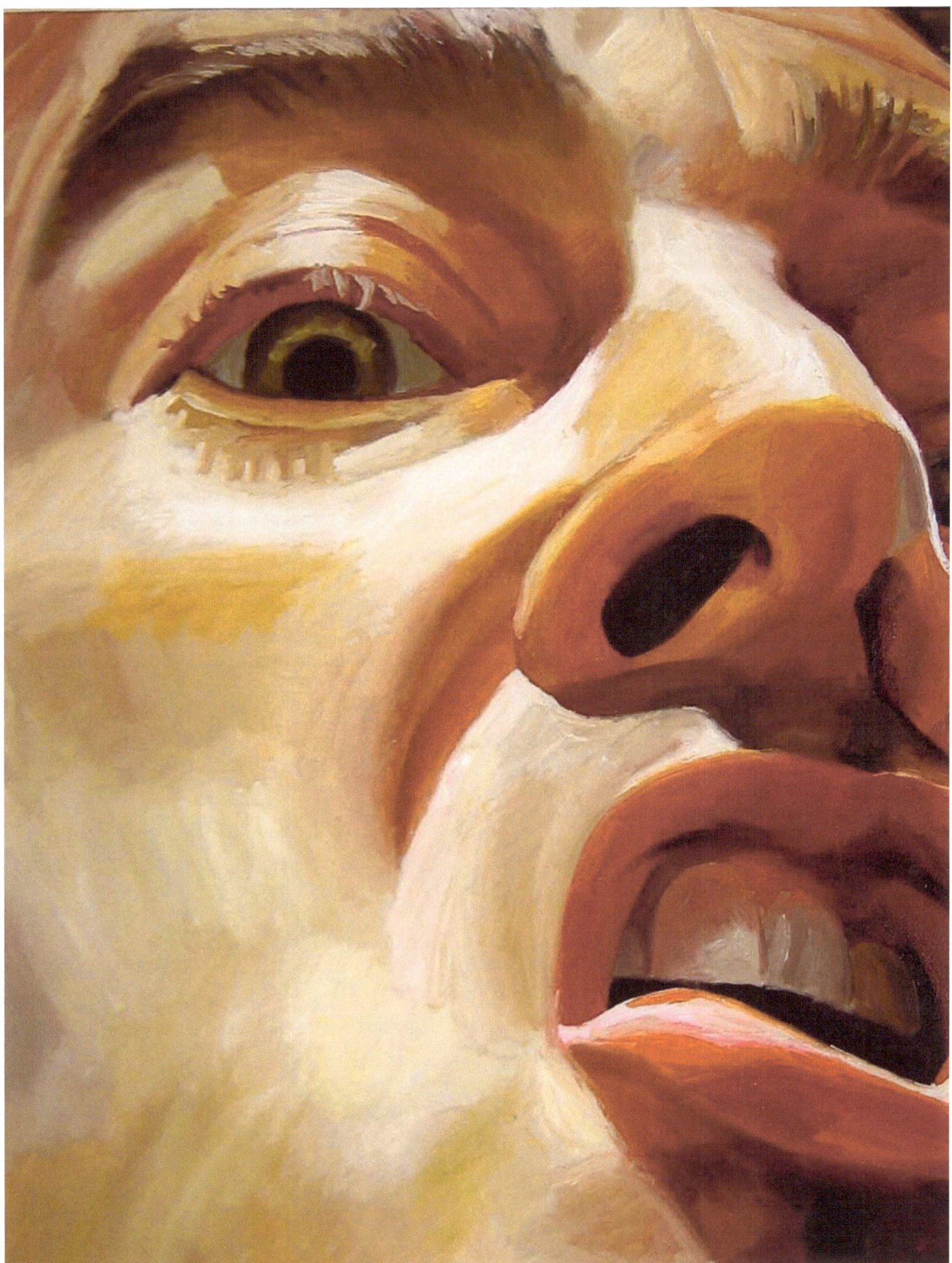

Eric Zener

My work reflects our collective desire for transformation into something ideal. In my paintings I seek to create a sense of sanctuary; often using the figure in water as a metaphor for renewal and reprise.. I believe that even in its ephemeral state, these places lift us – freeing us from the weight of our world.

Both you and Stephen Wright have work appearing in "The Time Being" a Tribeca Film directed and written by Nenad Cicin-Sain. Tell us about the movie and how you became involved with it.

The Director, Nenad Cicin-Sain is a long time friend of mine. Many years ago we worked on several video art installations that would be exhibited in New York and San Francisco. Our friendship has been full of creativity both in film and painting. In fact Nenad is often seen in many of my paintings when there is a male subject. With this film he asked me to help make the studio scenes feel authentic and to coach the actors on how to handle the brushwork and general studio work. Often times I would begin a brush stroke and then the actor (Wes Bentley) would follow the line of paint over mine. Some of the work was created earlier in my studio and some was done on set. It was a fascinating journey indeed.

I immediately recognized your work when I was watching the trailer and became very excited to see it shown in the trailer. However there were a few artworks at the start of the trailer which I did not recognize and later found out that it was your work. Did you have to step away from your comfort zone to work on those pieces?

The water work and the trees in the museum scenes are what I normally paint. However Nenad asked me to produce several black and white paintings of decaying fruit for an art opening early on in the movie. I left fruit out in my studio for weeks as it decayed and painted them in compositions that I thought were interesting. It was challenging, however also very freeing to do something unique and different to my normal approach.

How much of a time-frame did you have to work on the artwork selected for the movie?

Like I said earlier the majority of my work was already done - either in galleries or in my personal collection. The rotting fruit took a month or so to produce. I was able to cut corners, so to speak, as most of them were shot with quite a bit of distance from the viewer... so perfection was not an issue.

Does your own career as an artist relate to any of the main characters in the movie (the painter and the collector) or any of the other roles in the movie?

In some very general ways. I have three children, and as this is not a 9-5 career, as a father at times I do question the selfish nature of time when working late or weekends etc. It is a wonderfully flexible career, but with a family the balance of creative focus must be sequestered at times to read that bedtime story!

What are your personal views on the current art scene?

I think we are at the beginning of a new phase. The cottage industry that existed for so long is slowly opening with artists depending more and more on their own self promotion. Social media, access to so much information via the internet and the ubiquitous art fairs I think may be a foreshadowing of a more open market.

What are you working on next?

That's a secret.

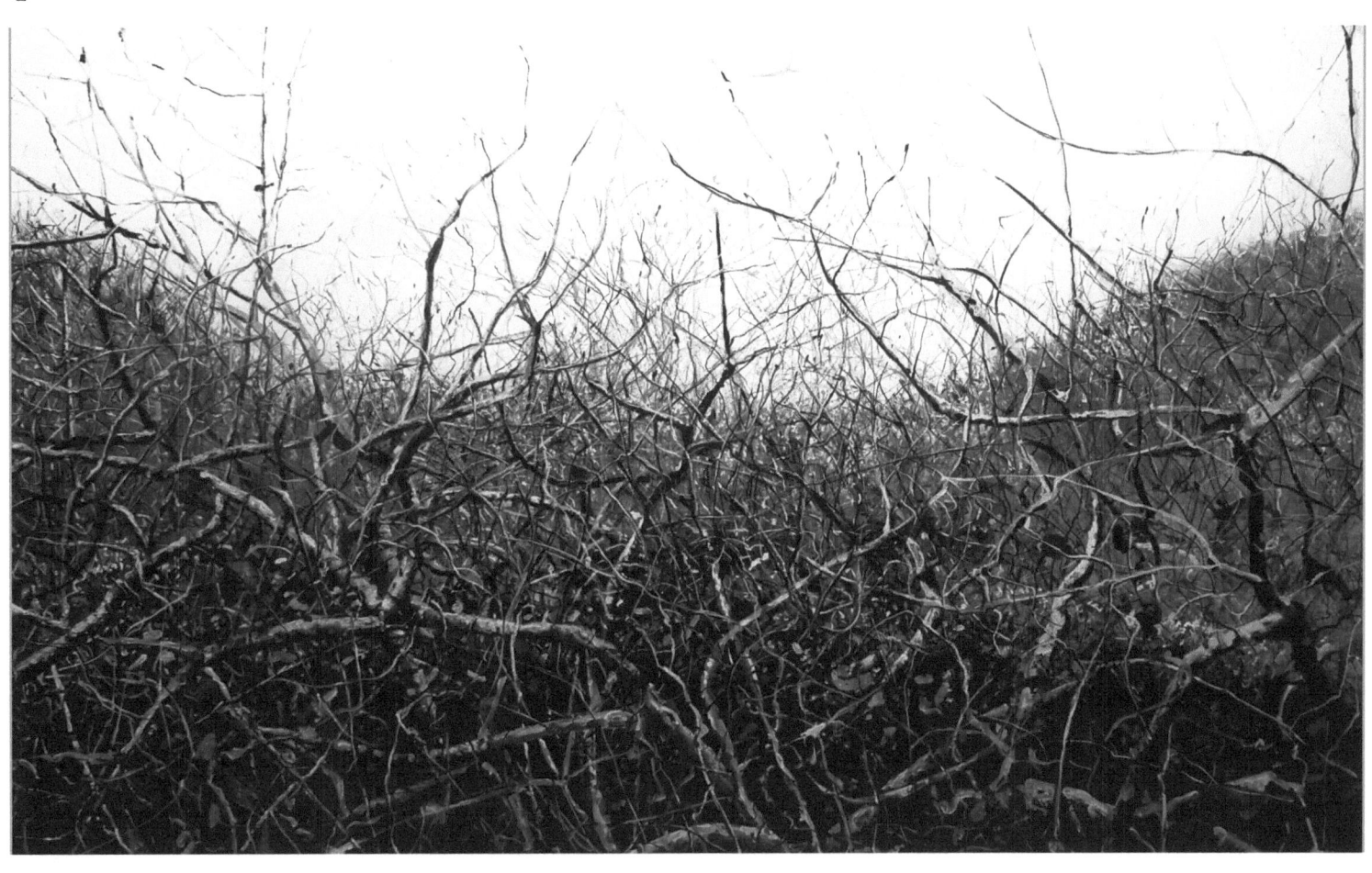

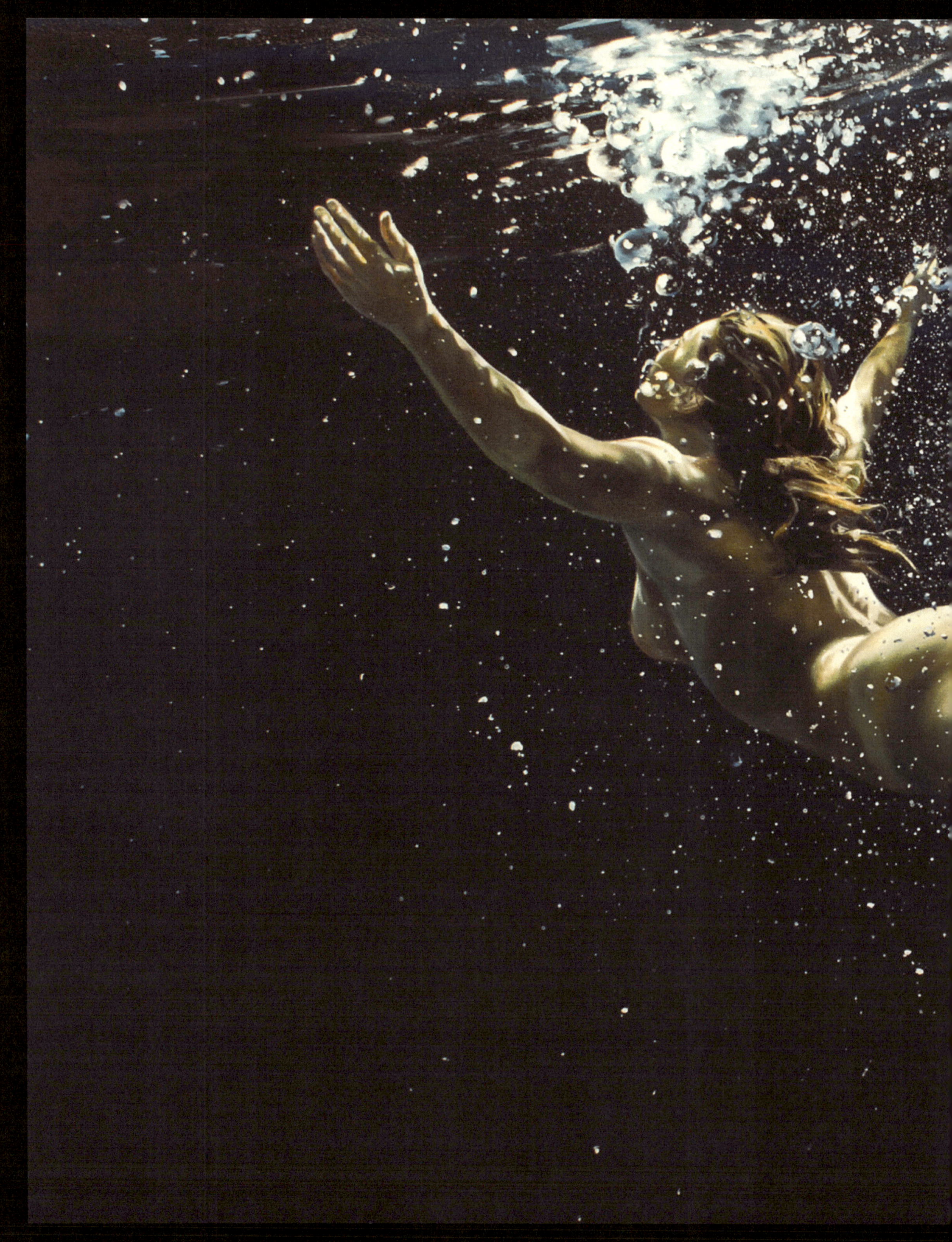

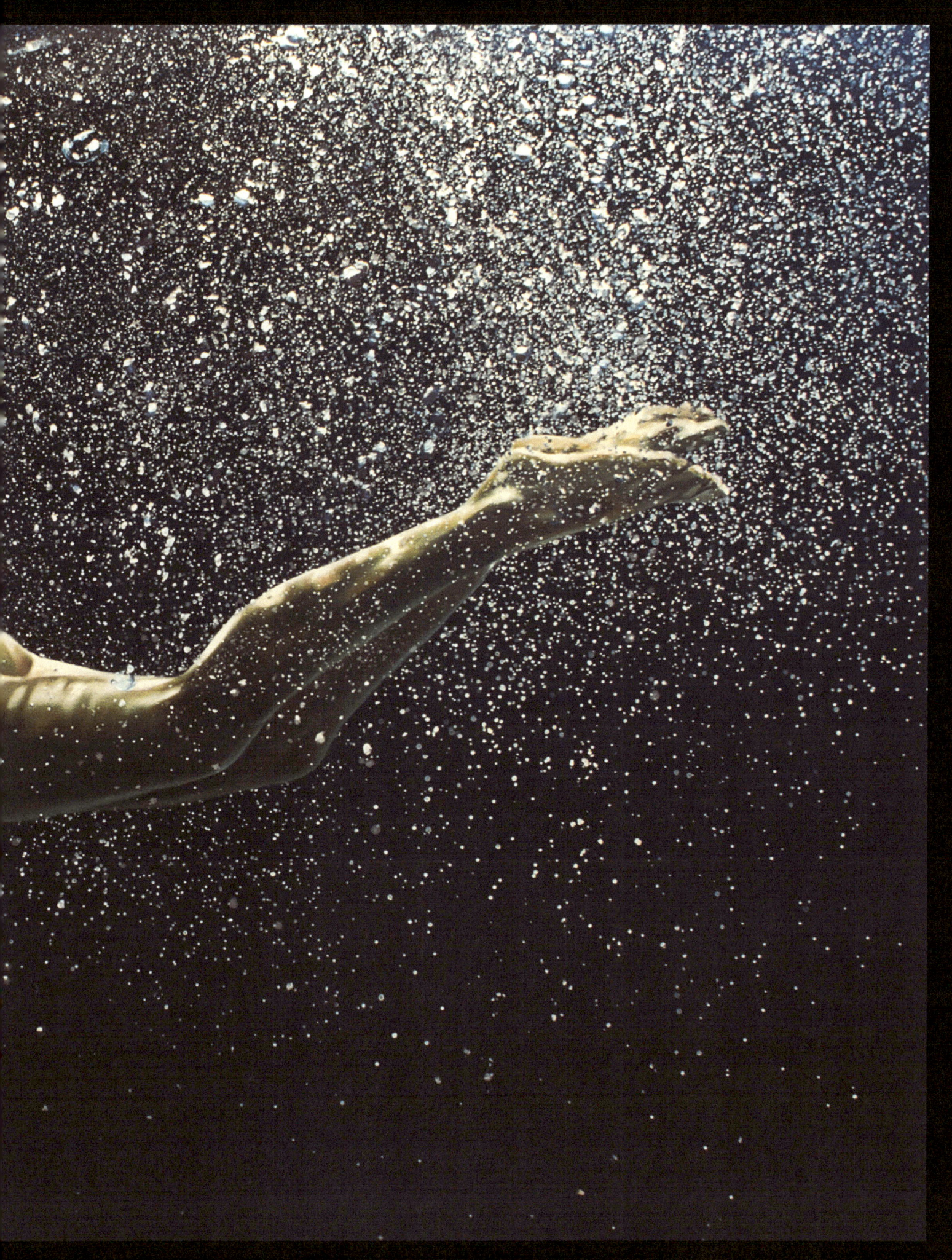

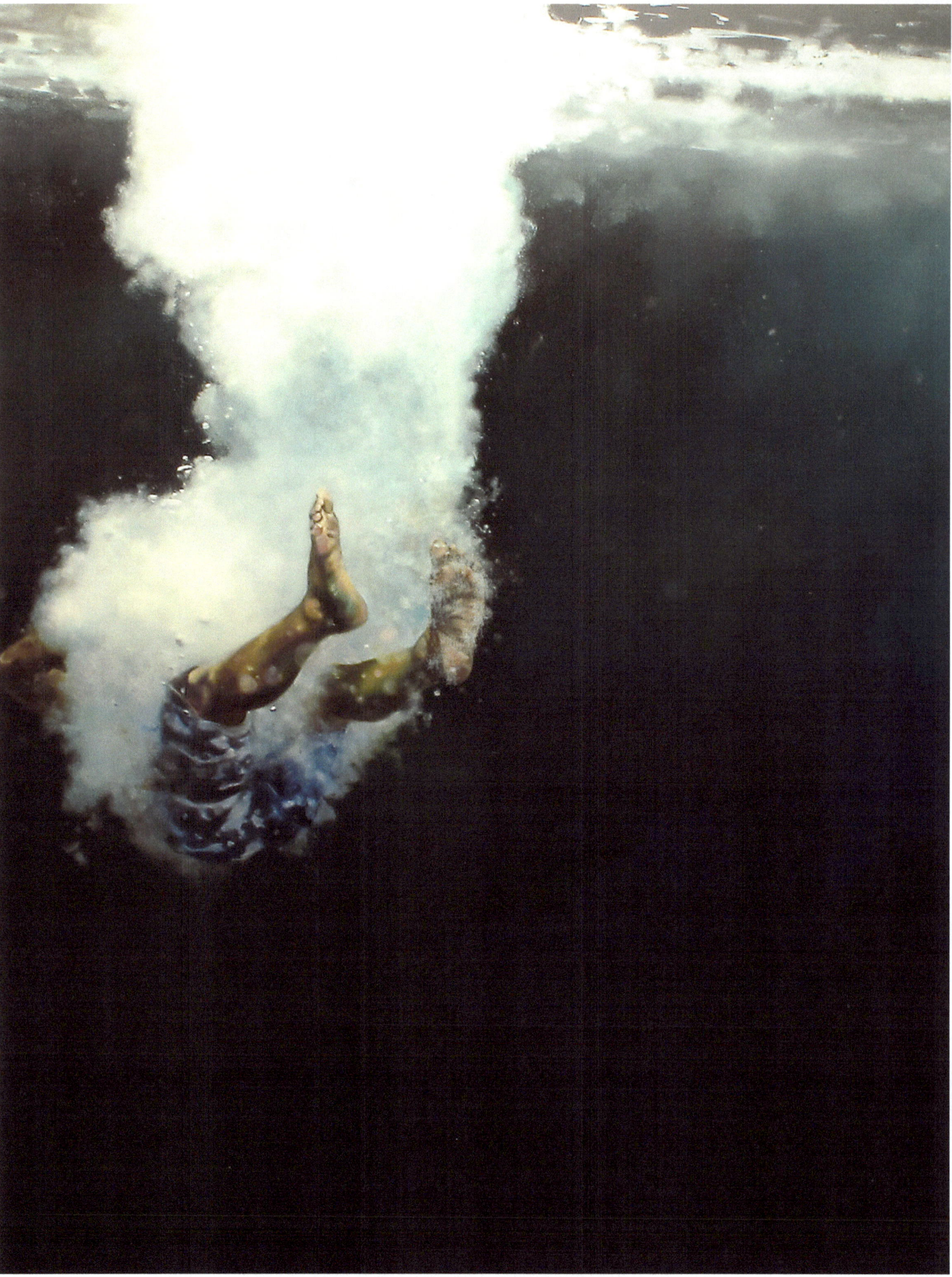

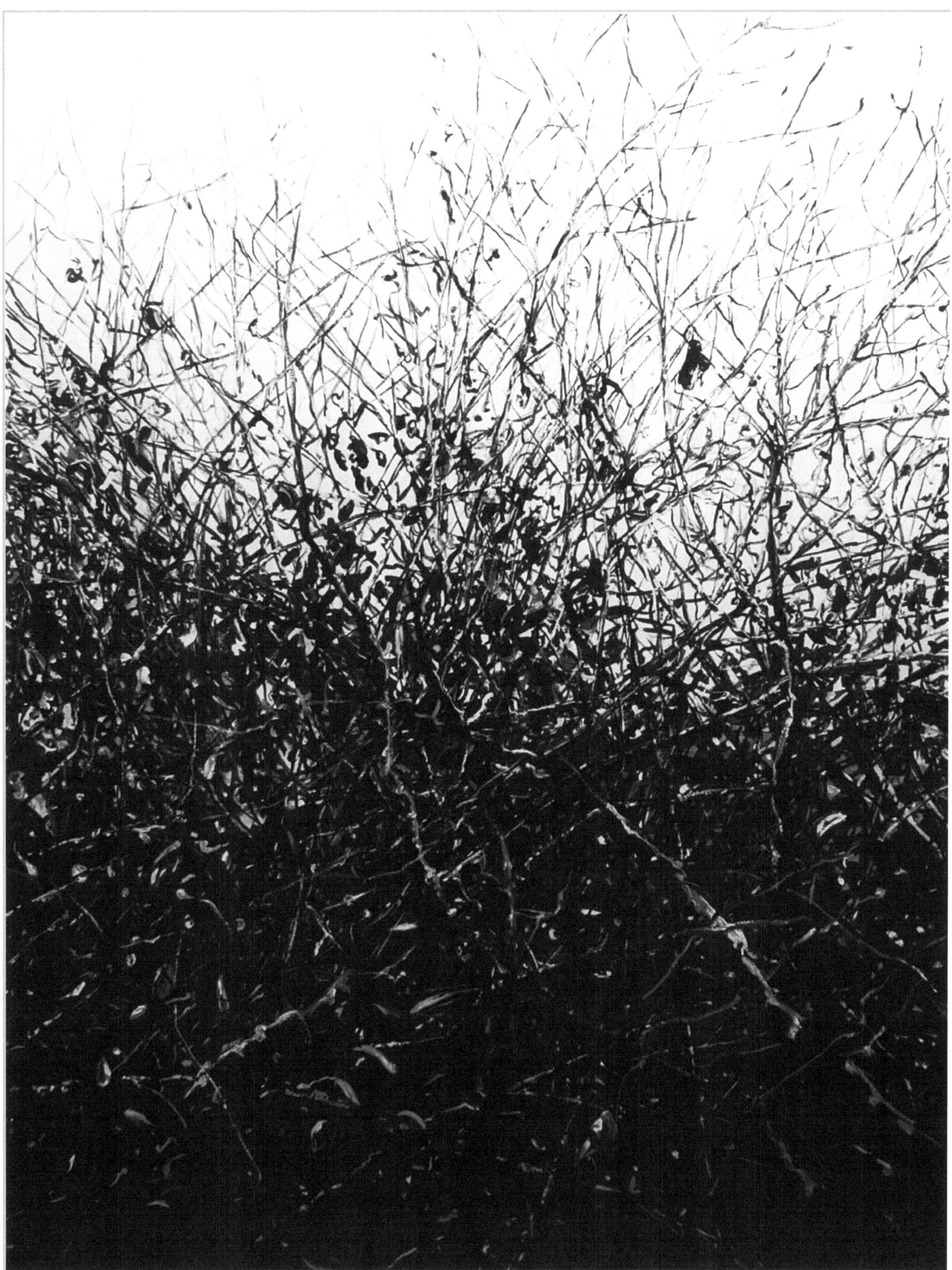

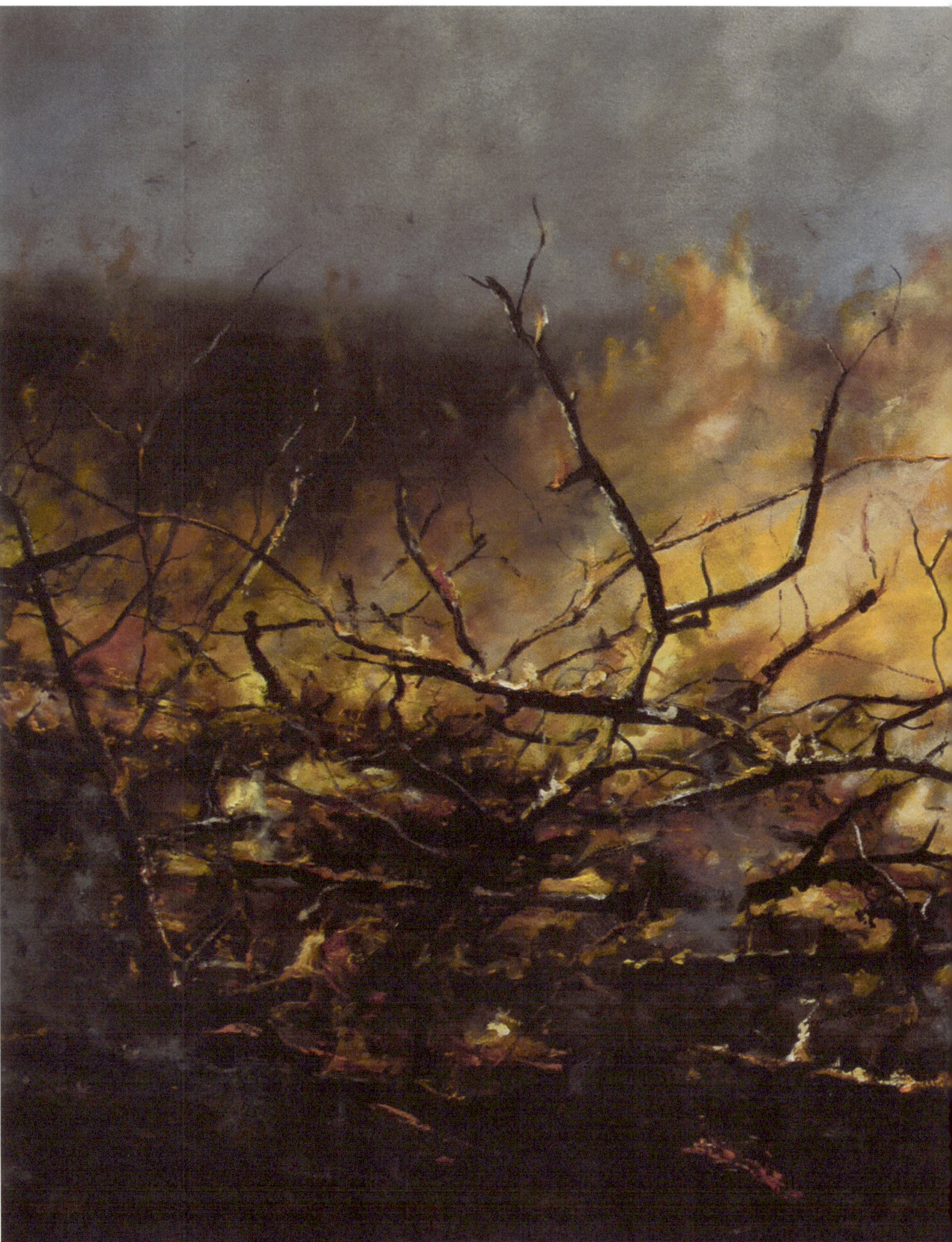

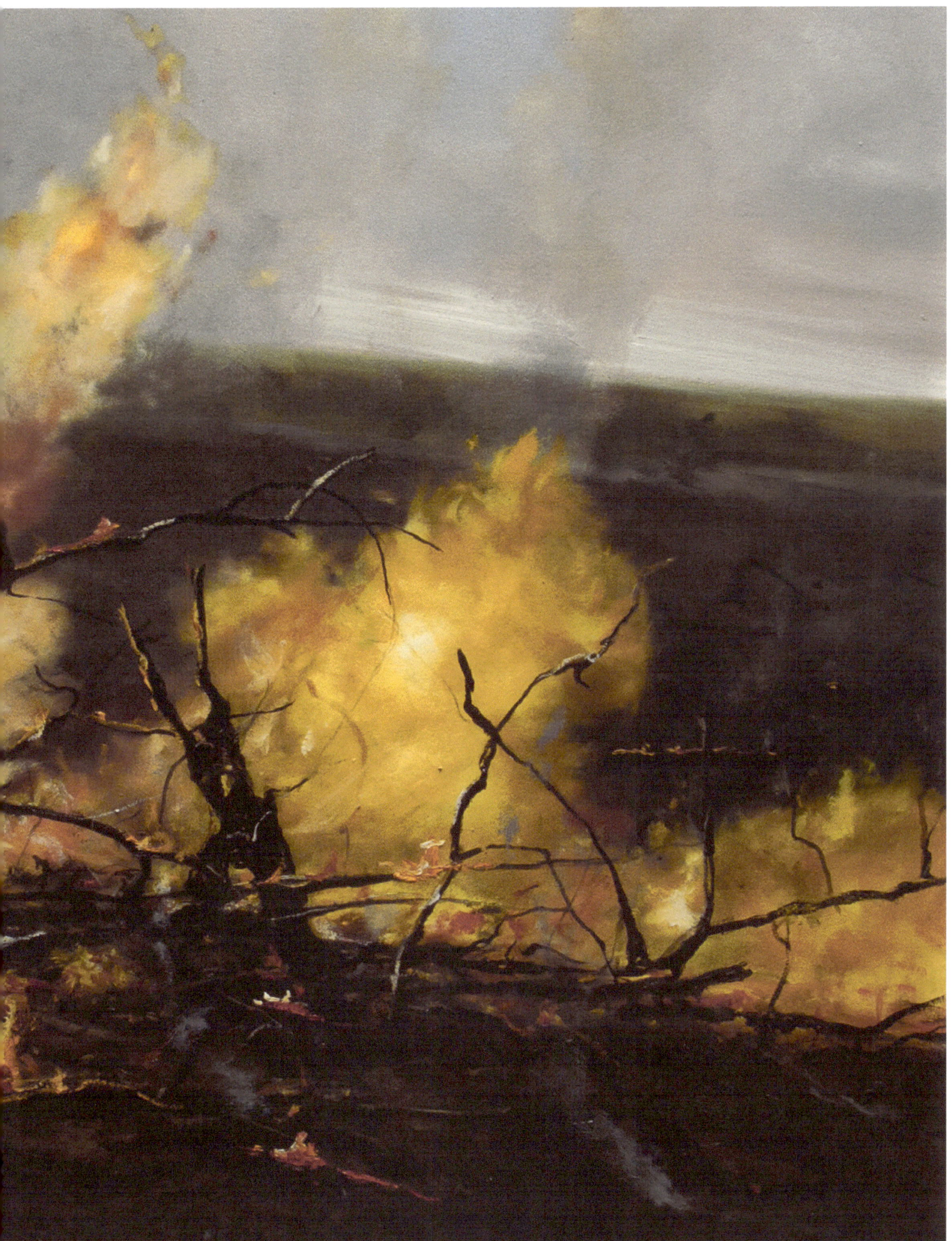

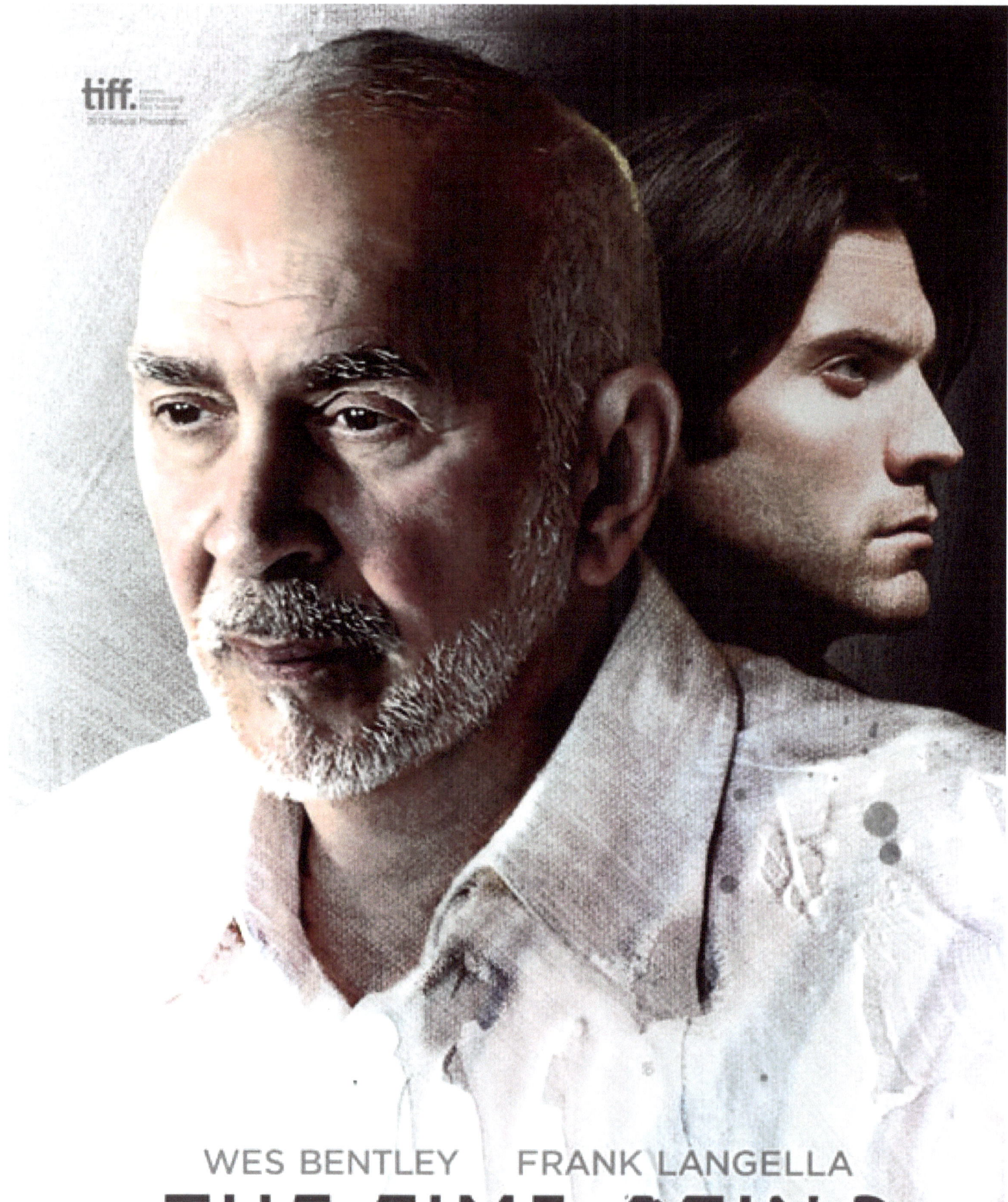

Tran Nguyen

Tran Nguyen is a Georgia-based artist. Born in Vietnam and raised in the States, she received a BFA in Illustration from Savannah College of Art and Design. She is fascinated with creating visuals that can be used as a psycho-therapeutic support vehicle, exploring the mind's dreamscape. Created with a soft, delicate quality, she executes with colored pencil and thin glazes of acrylic on paper. Tran is currently represented by Richard Solomon and Thinkspace Gallery.

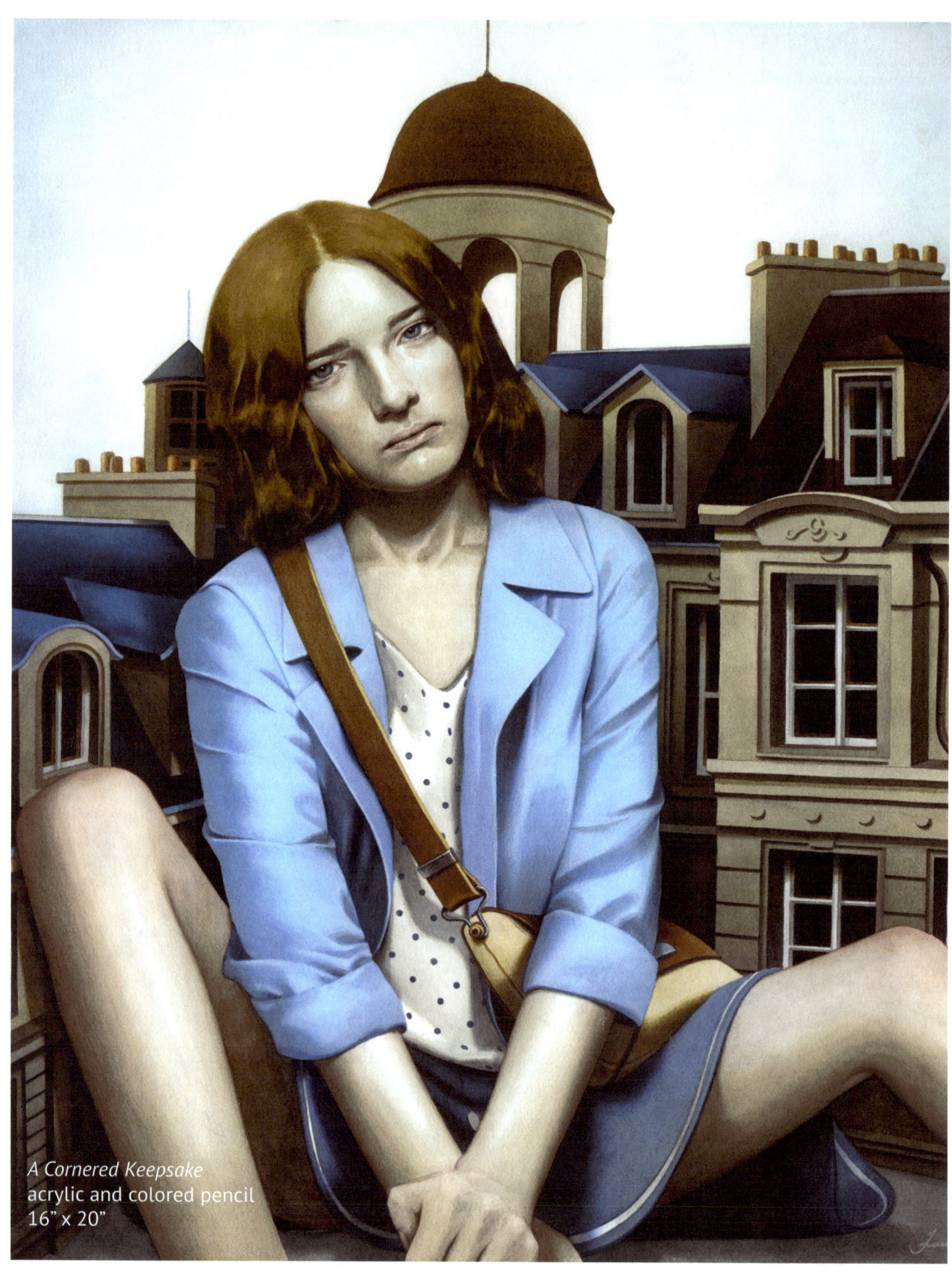

A Cornered Keepsake
acrylic and colored pencil
16" x 20"

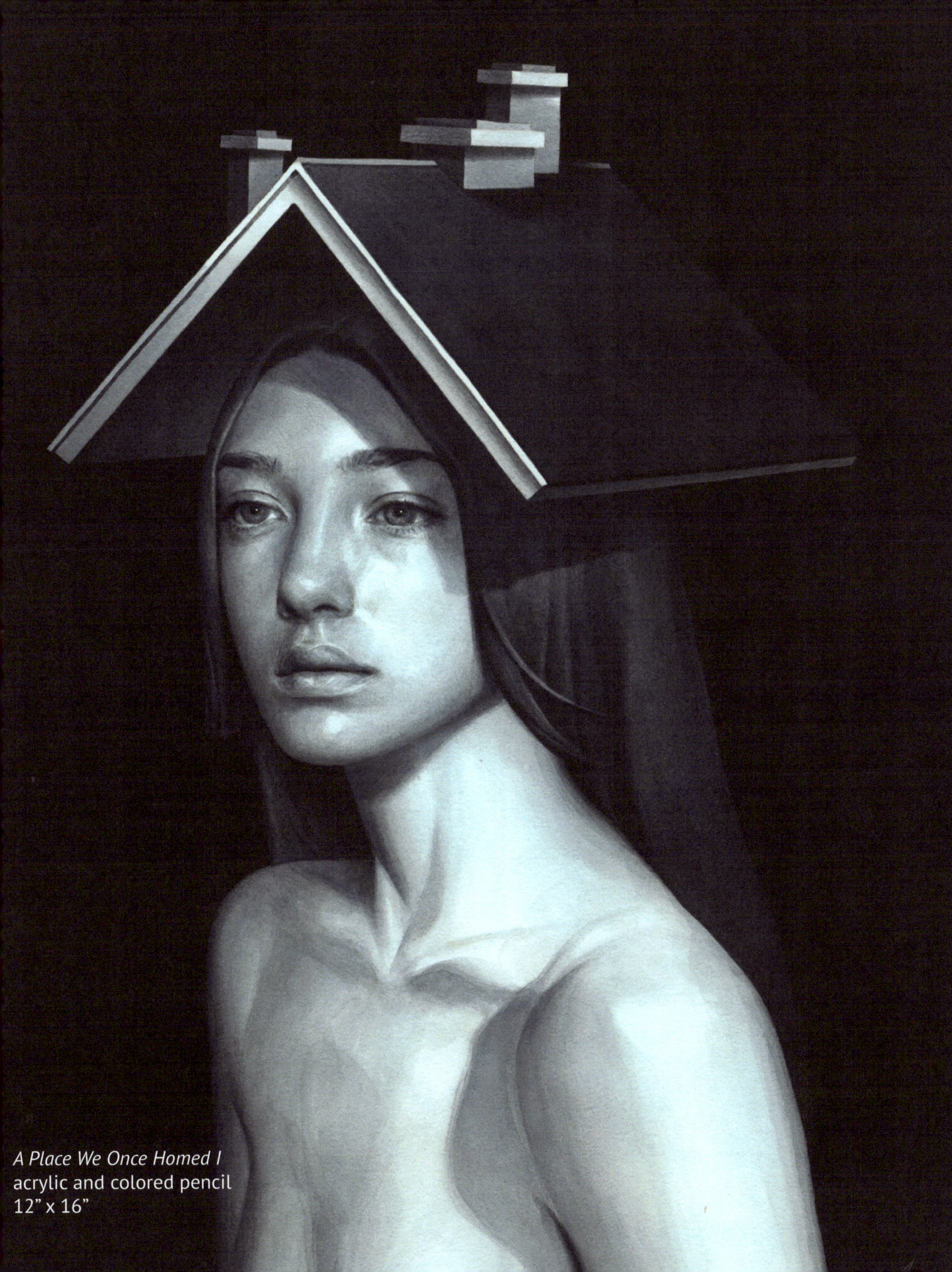

A Place We Once Homed I
acrylic and colored pencil
12" x 16"

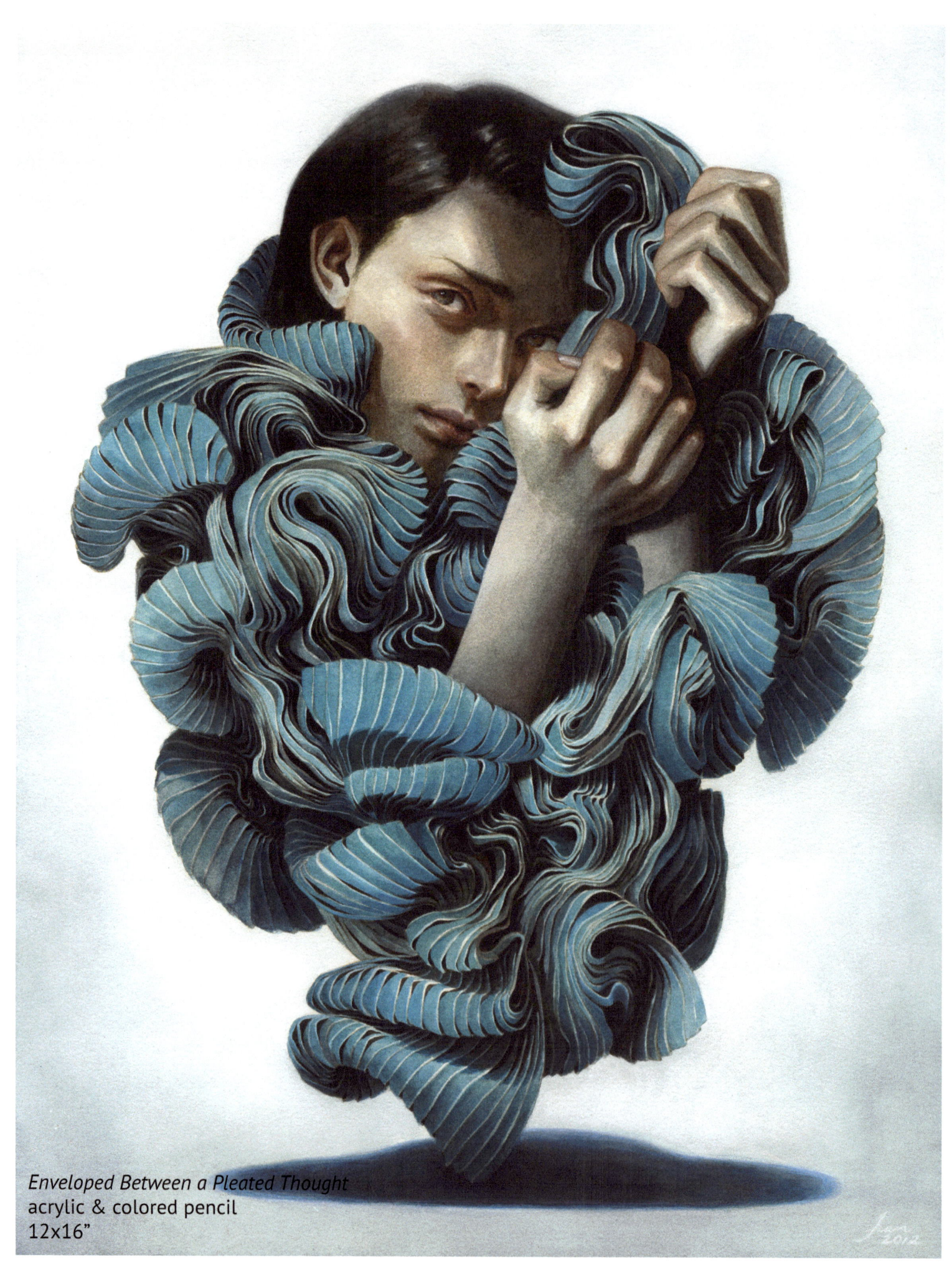

Enveloped Between a Pleated Thought
acrylic & colored pencil
12x16"

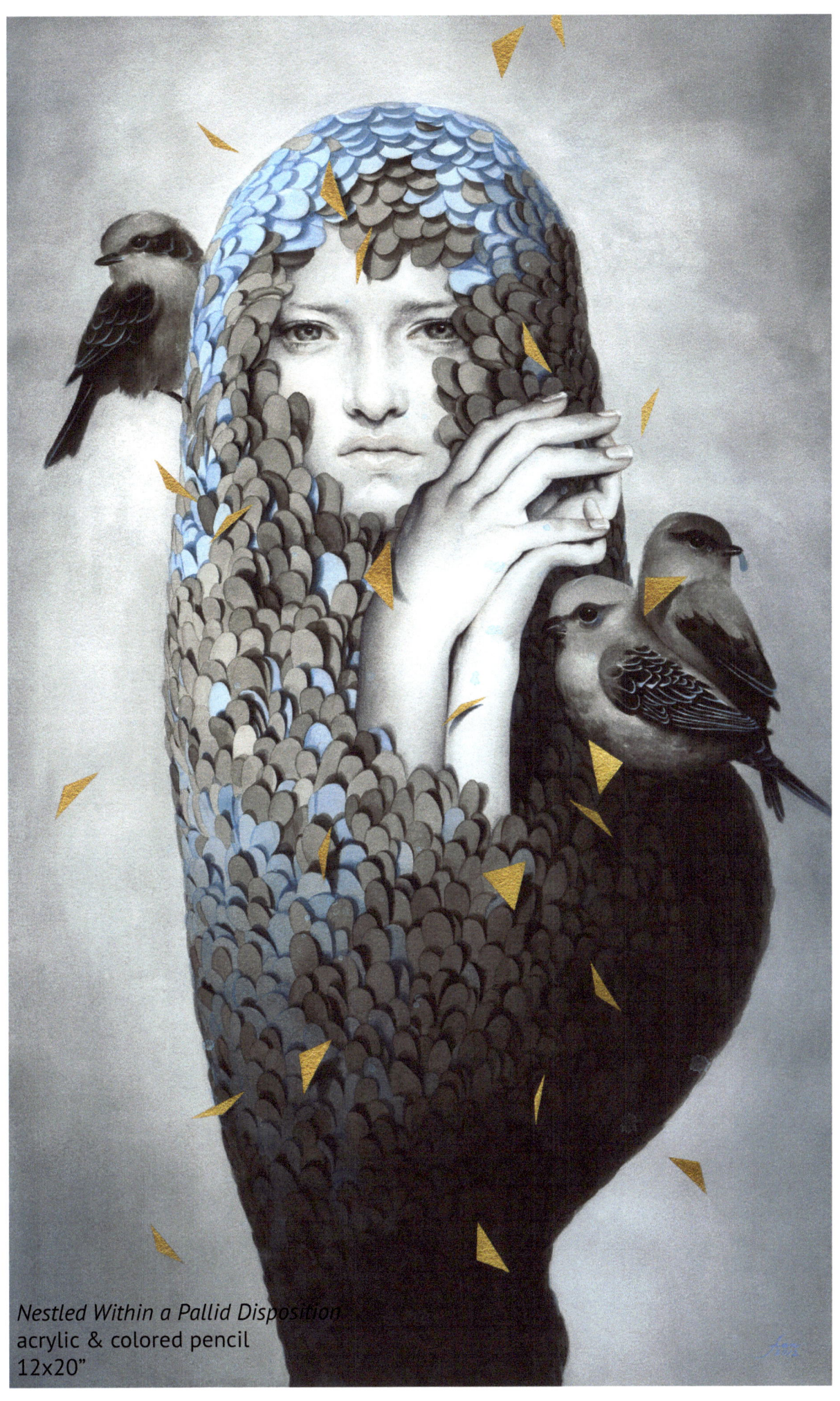

Nestled Within a Pallid Disposition
acrylic & colored pencil
12x20"

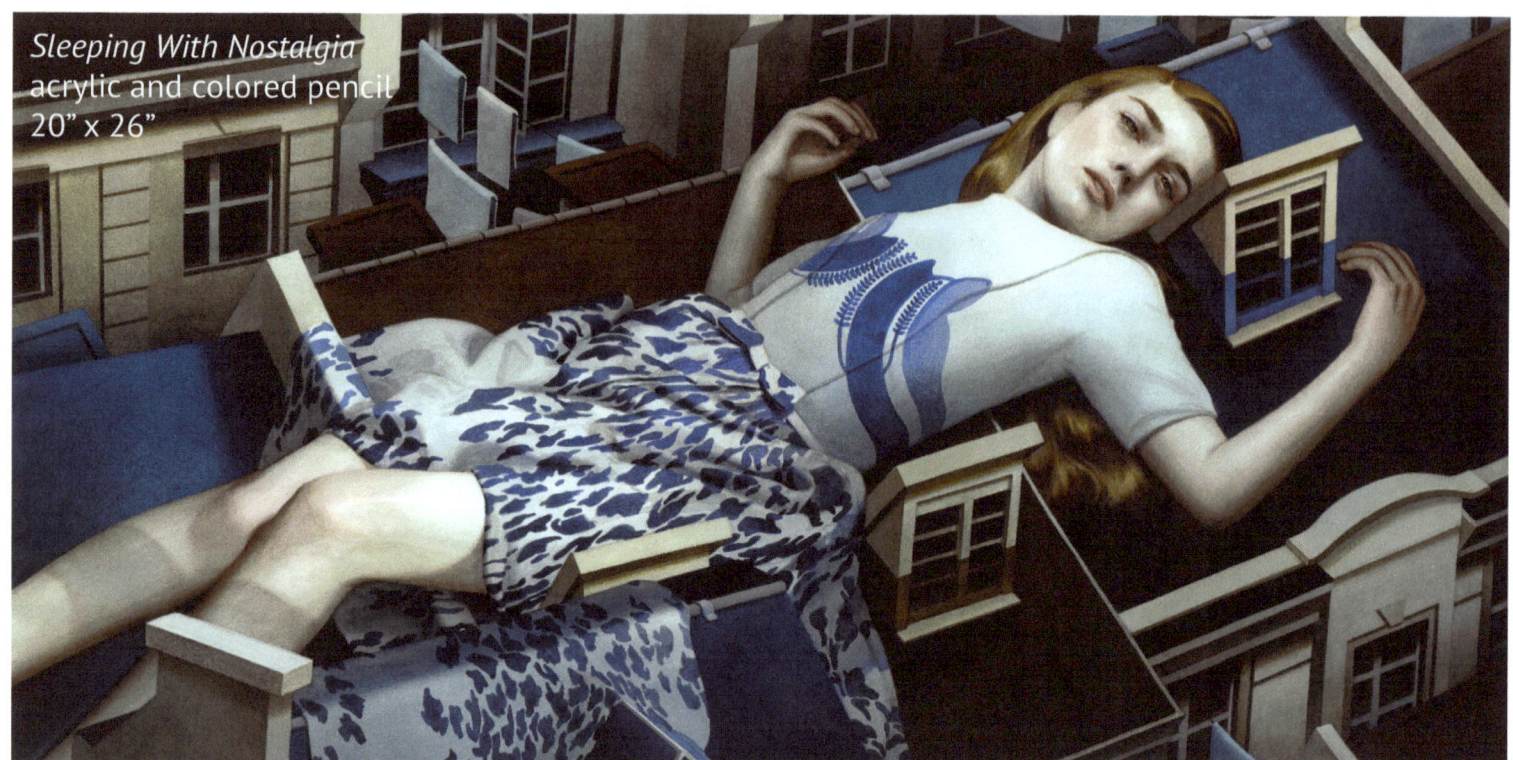

Sleeping With Nostalgia
acrylic and colored pencil
20" x 26"

Tran Nguyen is a Vietnam born, Georgia based artist who mobilizes her illustrative imagery as a vehicle for latent psychic experience.

As haunting dreamscapes, the narratives that emerge from Nguyen's works are at once uncanny and eerily relatable. Suspended somewhere between waking consciousness and the subconscious, the imagery she unfolds feels as spontaneous and creative as the wanderings of free cognitive association. The stories that emerge from her pieces are charged with familiar psychological themes, everything from the phobic object, to the transformative metamorphosis, to the personal fantasy, but in the artist's hands, far from being contrived, these stories feel organic, immediate, and beautifully eruptive, as though they have unfolded effortlessly. It is this illusion of effortlessness that makes the work feel truly liminal. Looking into these images we are elsewhere, we are other, we are held by an ambiguous suspension of reality. At times the artist's strategies feel dark and haunted, but the beauty and delicacy with which they are rendered attenuates any feelings of anxiety or distress in their presence. This combination of charged content with delicate and luxurious execution make Nguyen's vision truly magnetic.

Tran Nguyen's pieces are deliberately and delicately rendered with subtle washes of diluted acrylic, and detailed applications of colored pencil. Her aesthetic and rendering convey affectively charged psychological landscapes, dreamy, sensual, surreal, and fantastic, like the hyper-real of the "elsewhere" in the truly immersive dream. The juxtapositions in Nguyen's work are fascinating. Unlikely pairings, and unexpected contexts emerge with seductive clarity. We are left with the feeling that nothing is extraneous, and that everything is connected to some ultimate symbology within the work. In the tradition of truly consummate illustration, each symbol, each suggestion of imagery, each object, is part of the narrative "moment", and everything has its place. The artist's interest in imagery as a vehicle for healing, combined with her masterful rendering of textures, skin, shadows and folds, speaks to the work's deeply psychological valence. From the recesses of the unresolved, emerge beautiful lush images; like exorcisms through imagery. While the work is evasive in its symbolism, something raw and relatable draws the viewer into the experience. The work luxuriates in the baroque excesses of the dream.

-Marieke Treilhard

Edward Nudelman

Disco Cool

What started disco ended disco. When the sun was born it was hot and sweaty. It was blistering. So God said, let there be cool. And about 20 millions years later there was cool (it takes time to make cool). A multi-faceted light accelerated toward earth, landed in the middle of a dance floor, jumped to the ceiling and rotated on its axis in gyration with sound. Men's voices jumped three octaves and a strange virus circled the earth causing high fevers on Saturday nights. Everything was cool for about ten years until John Travolta turned cool into way cool, dance floors cleared and discos no longer played disco. Cool started disco, cool kept it going and too much cool ended it.

"I write poems when I'm not divining water or digging up bones. I've got a couple books out there and a bunch of poems in a bunch of journals. I used to be a scientist but I gave that up for a more lucrative writing career. For more information, please google Edward Nudelman, cavedweller. "

Grace Cavalieri

I'll take that as a compliment

Dancing in the basement of the Pentagon
every Friday night— they'd open up for
disco lessons and how we'd been waiting
to learn those steps. Elaine the accountant in
my office would come with her new boyfriend
although his little kids vomited on her
their first time at the picnic,
but maybe they could make it after all to
this kind of carefree bouncing fast music.
Her husband locked her out and kept the
family punch bowl, and Ken and I were badly
in need to find something new in our marriage.
This just might be it, finding the moves to
Donna Summer urging us on. Oh yes, they
pushed the desks aside to clear the space
for continuing education in the Pentagon
basement for people like us, except the
only trouble is we both wanted to lead. We
learned the grapevine and the side wind and
outlasted Elaine and Ted, but every week
we found we needed to start all over again.
Maybe if we had a strobe light, my husband
said. I'm willing to. Are you?

"I was a Wife, Mother and Writer for 59 years. Now, I'm no longer a wife, but I am still a Mother and a Writer. Also as a radio producer, I've presented poets on public radio for 36 years."The Poet and the Poem," still going strong, is recorded at the Library of Congress, With 16 books and chapbooks of poetry in print, my greatest pleasure has come from the publications issued by GOSS183, which include Millie's Sunshine Tiki Villas; Anna Nicole:Poems; and Navy Wife."

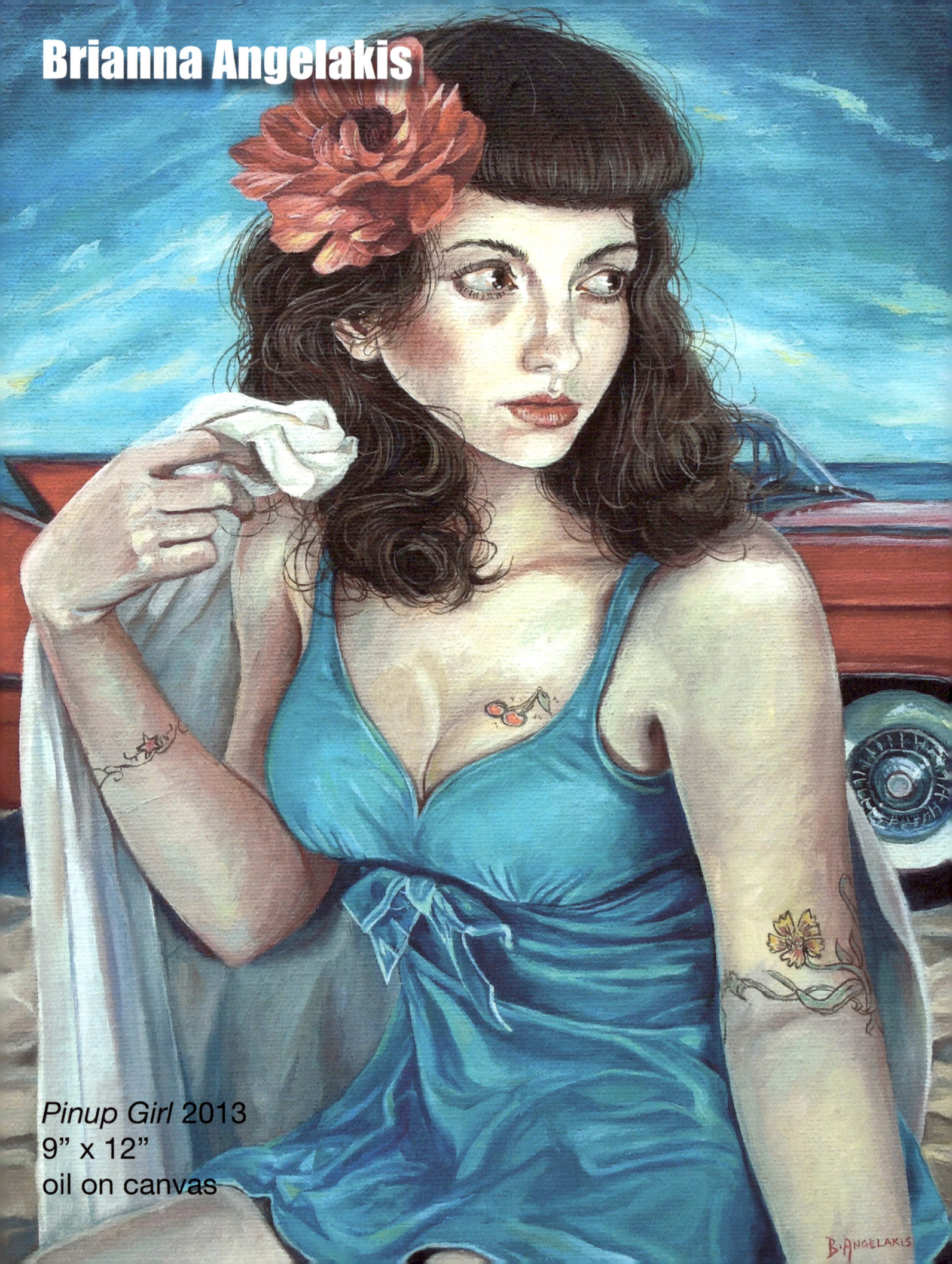

Pauline Aubey

Blow
Acrylics, pastels and marker on cardpaper
12/16 inches

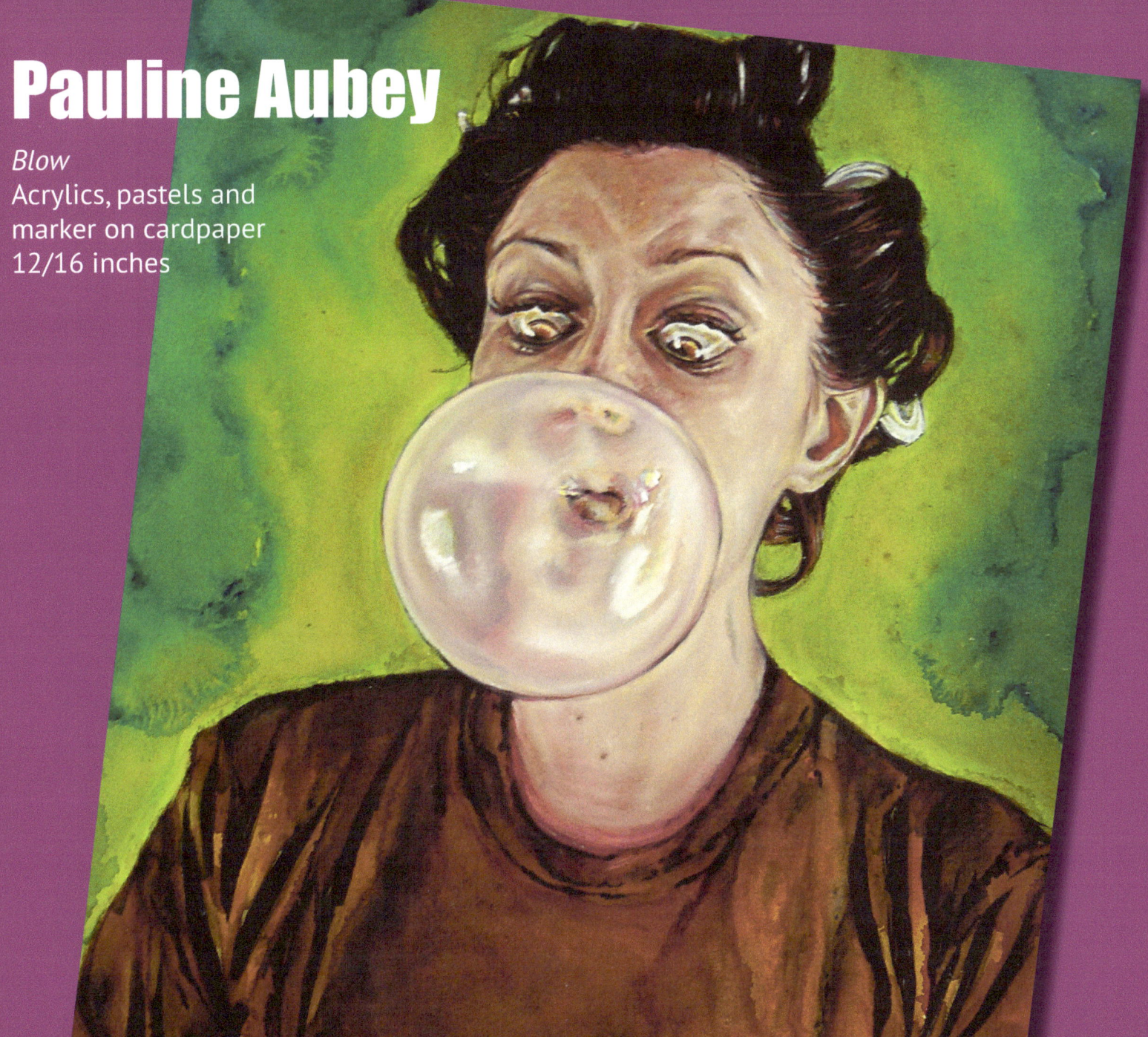

"I have always been attracted to the glossy surface of pop culture imagery while being strongly aware of its vanity and the complexity of the human reality lying underneath.

My work emphasizes this dichotomy by mixing pop and naturalistic ingredients, thus creating a playful yet unsettling atmosphere.

I like to focus on the psyche of my subjects, who appear tensed in a surrealistic setting, visibly suffering from a sweet alteration. They are both exposed and impenetrable, while my obsession with textures makes their rendering shift from the plastic to the organic.

Recently I have privileged the use of mixed media so as to obtain an adequacy between form and content by the coexistence of sharp pen lines and opaque colorful zones that highlight the discrepancy between surface and depth."

www.poupeedechair.deviantart.com

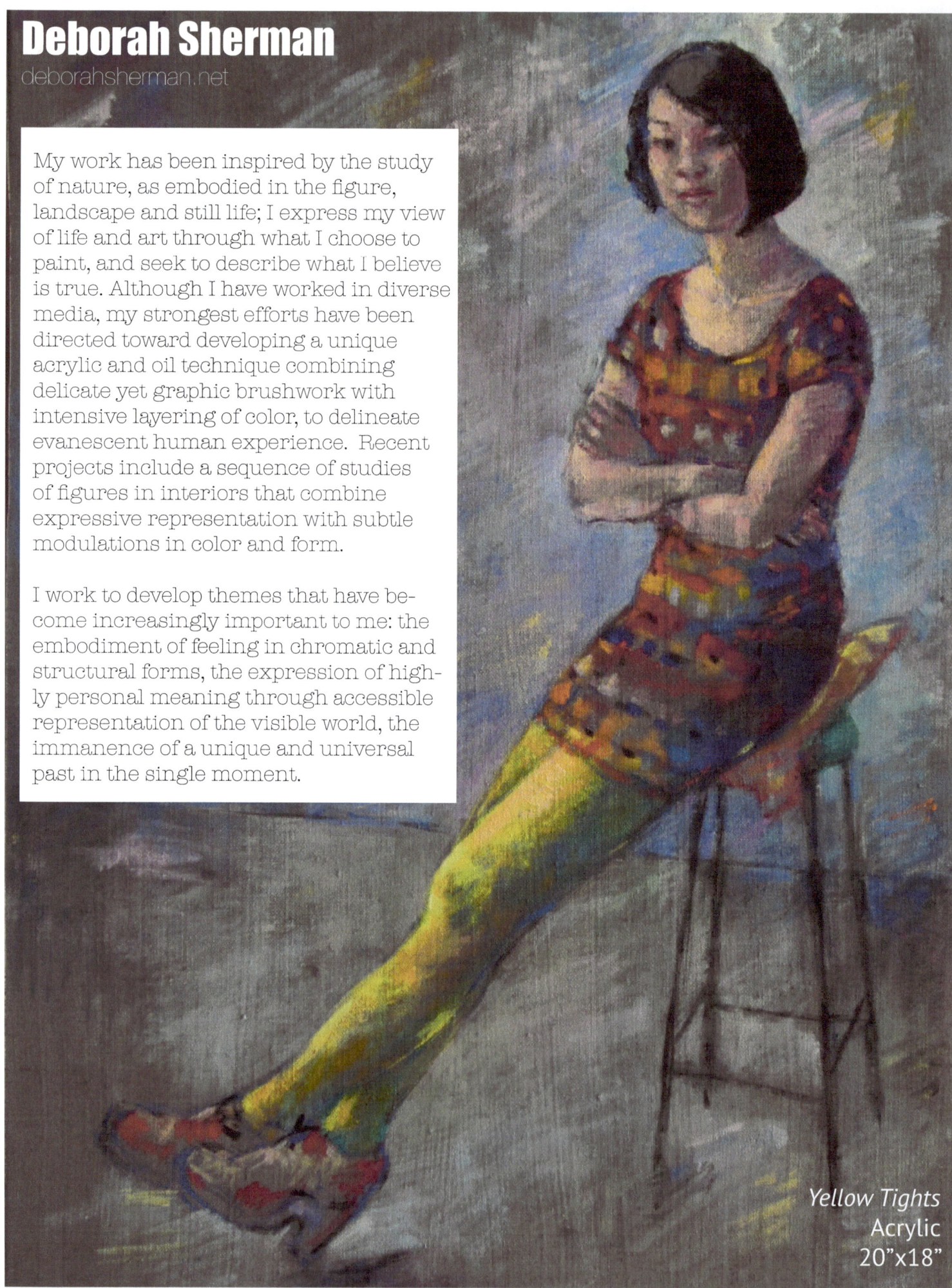

Deborah Sherman
deborahsherman.net

My work has been inspired by the study of nature, as embodied in the figure, landscape and still life; I express my view of life and art through what I choose to paint, and seek to describe what I believe is true. Although I have worked in diverse media, my strongest efforts have been directed toward developing a unique acrylic and oil technique combining delicate yet graphic brushwork with intensive layering of color, to delineate evanescent human experience. Recent projects include a sequence of studies of figures in interiors that combine expressive representation with subtle modulations in color and form.

I work to develop themes that have become increasingly important to me: the embodiment of feeling in chromatic and structural forms, the expression of highly personal meaning through accessible representation of the visible world, the immanence of a unique and universal past in the single moment.

Yellow Tights
Acrylic
20"x18"

Diego Quiros

"Since the late 90's my visual work has progressed from stained glass and mosaics, to oils and acrylics, and most recently, to photography. My early influences were the work of the Pre-Raphaelites, Art Nouveau, and Symbolist painters who believed that art should represent absolute truths that could only be described indirectly. I have also experienced the same power of the unsaid in the haunting photography of Michael Kenna, the early work of Josef Koudelka and his ability to capture the presence of the human spirit amidst mostly dark and empty landscapes."

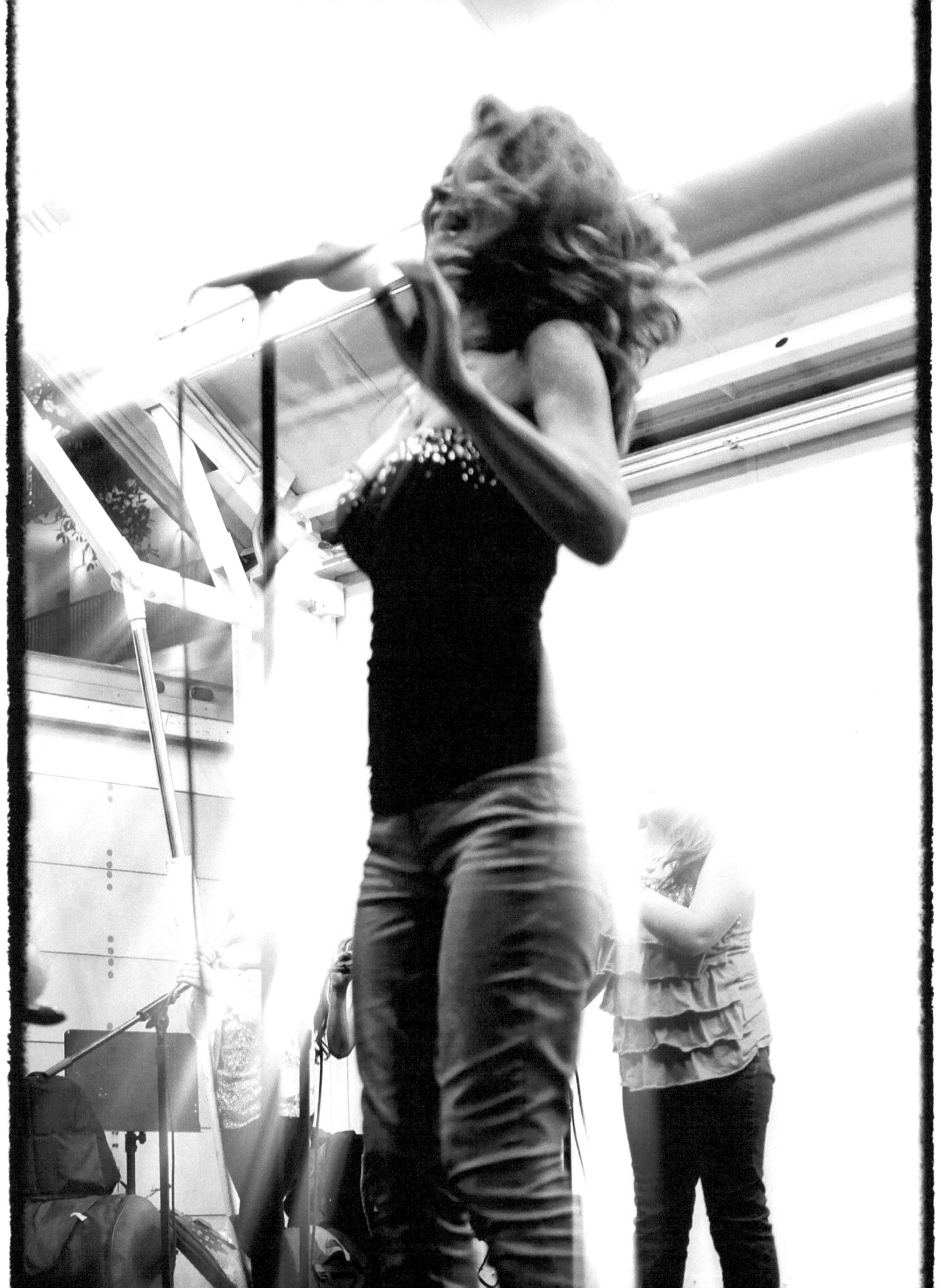

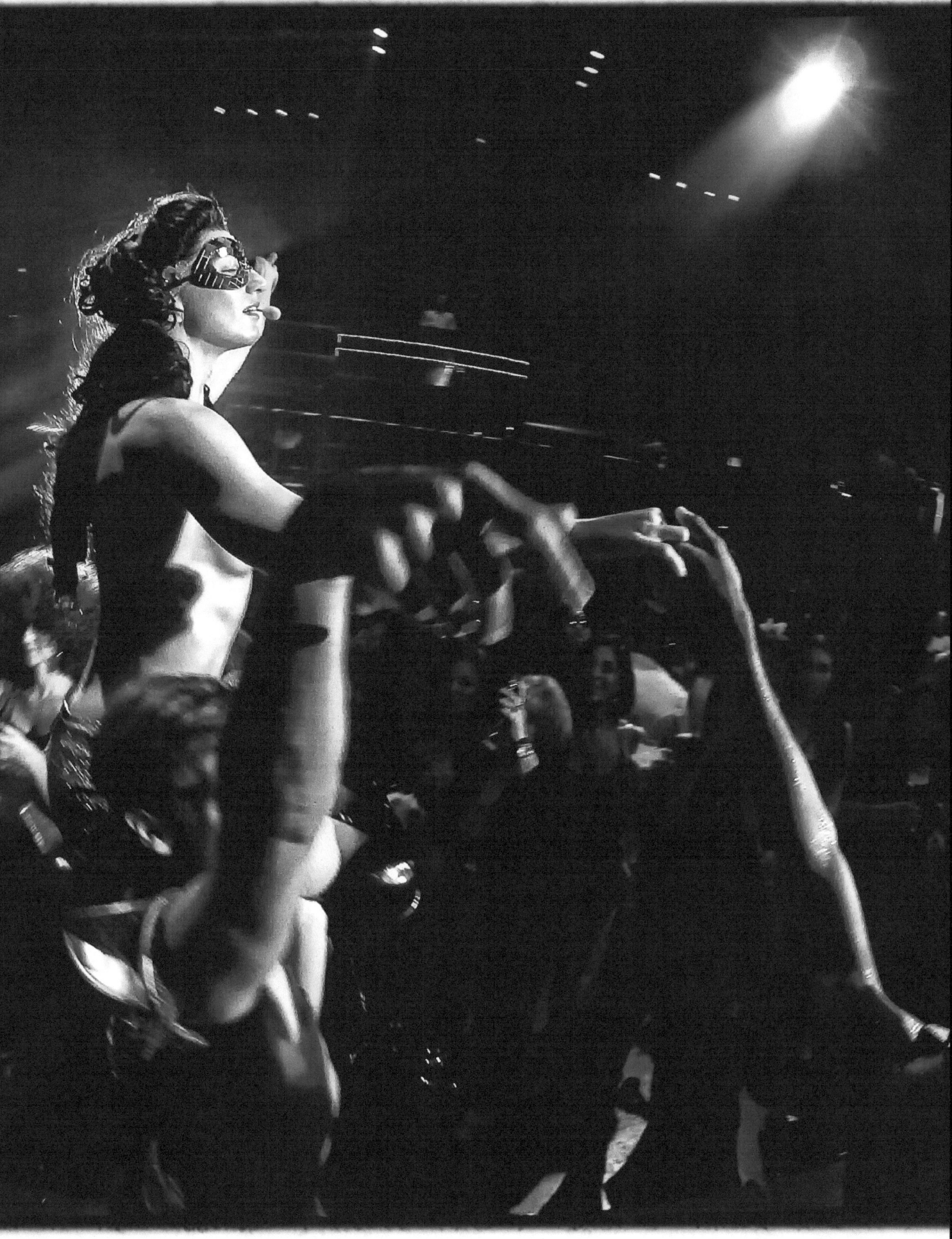

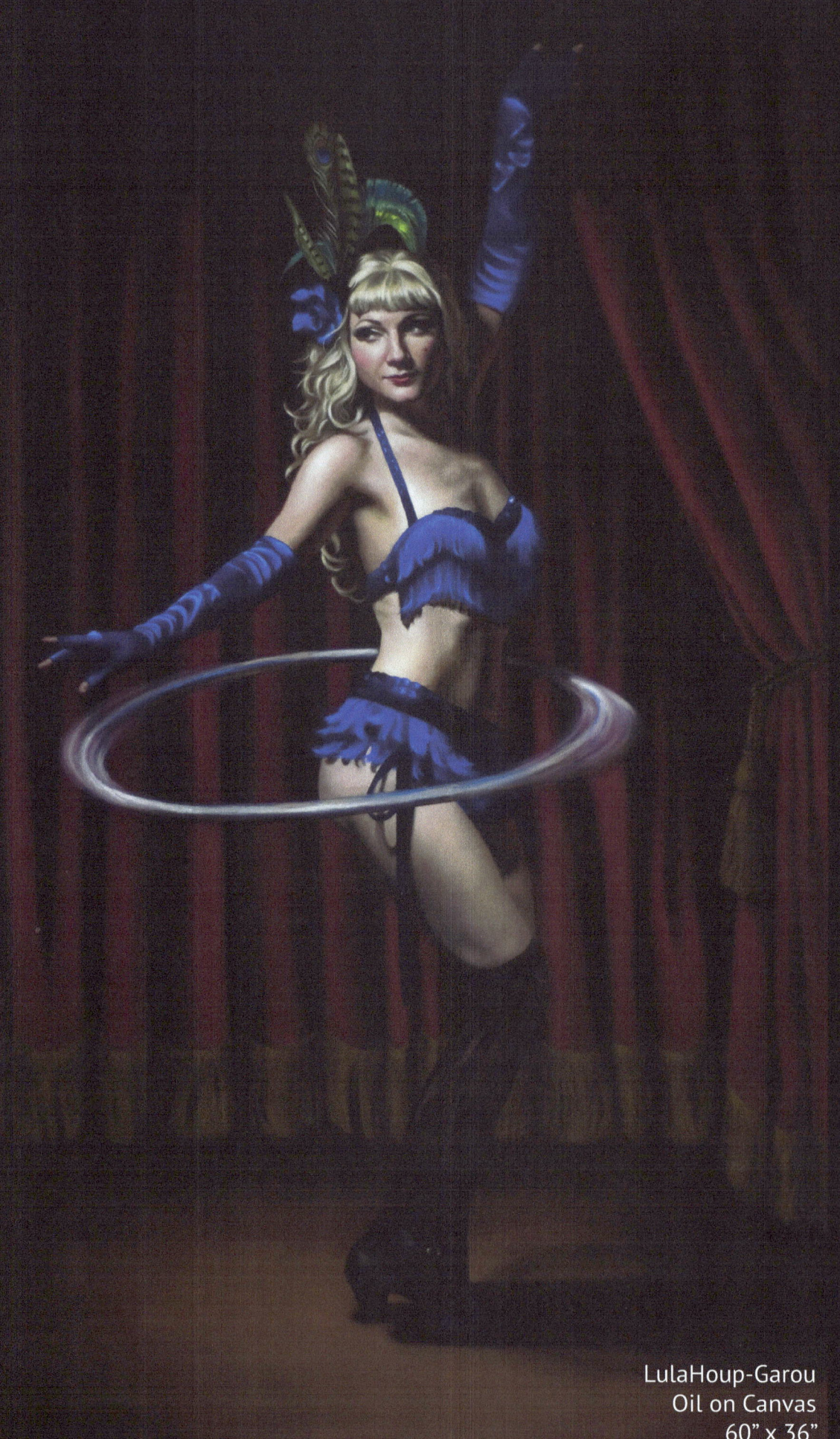

Lacey Lewis

LulaHoup-Garou
Oil on Canvas
60" x 36"

Richard J. Frost

"I graduated with a BFA from Otis/Parson 1991. My favorite subject matter is the dysfunctional side of life. I love the absurdity of it all, even when it comes to serious matters. If you see me coming at you with a paint brush, run! Because I have no mercy."

The Shady Bunch

 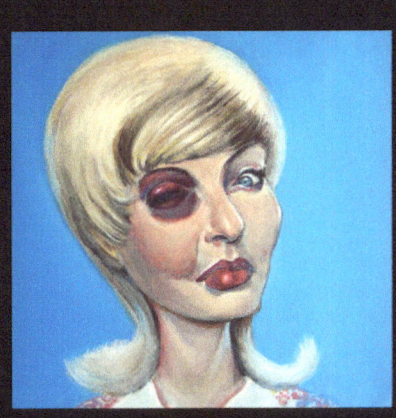 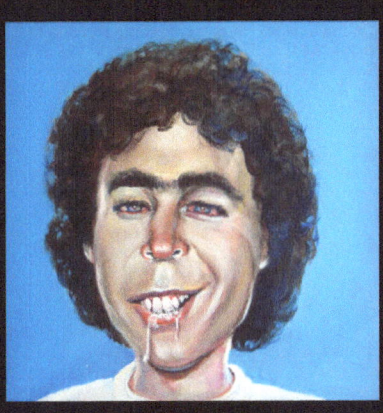
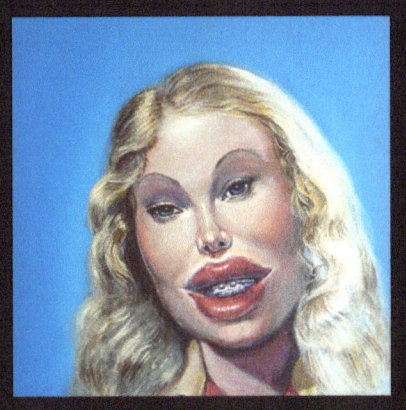 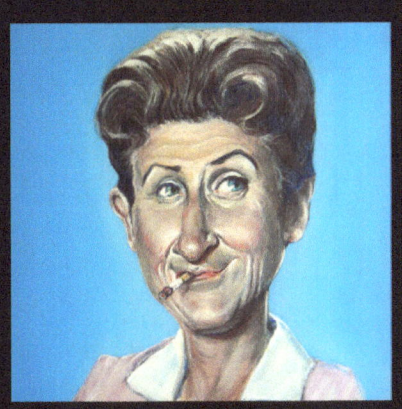 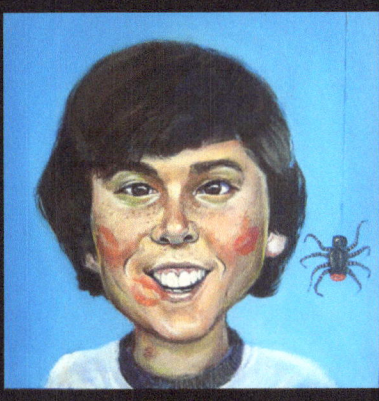
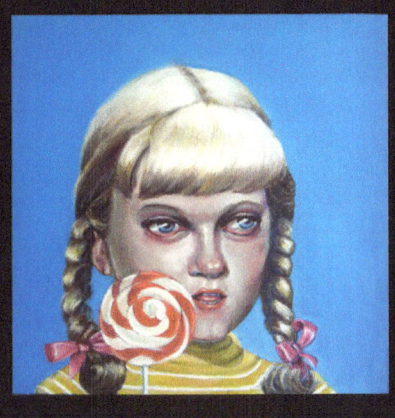 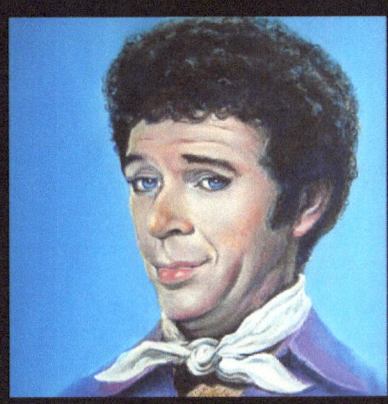 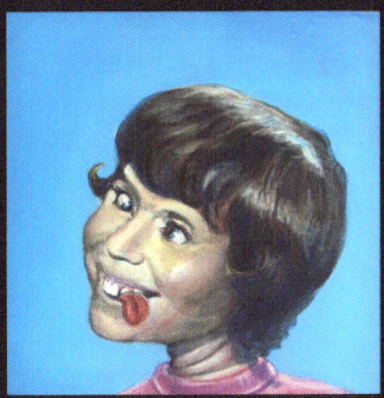

Aunt Jenny ("The Brady Bunch" Season 3/Episode 17)

Who dare call you a spinster?
You psychedelic carpet bagger, soul sister.
Entering a room like a bellowing "Charge!"—
bear hugs for all—in your neon purples,
oranges, and magentas. Even Auntie Mame
would shrink like a violet beside you,
suddenly feel plain as any old Jane.

No one's mother, no one's wife, dangling
like your earrings (a gift from some guru
or prime minister?) you tell your great
nieces and nephews "Traveling is the spice
of life." How—"the groovy thing about a sari
is—you don't have to wear a girdle ..."

A natural name-dropper. Pushing sixty
but still a floor plopper for an honorable
Japanese ceremony, slurping your tea while
phone calls spill in from your secretary:
an invite to Ari's yacht ("Jackie—she's a real trip!"),
then another proposal from that senator ...
"Balderdash!" You just continue to teach this
circle of six kids the proper way to sip.

And in your carpet bag: Such gifts. Such tricks.
For Marsha—a shofar, to blow in Rosh Hashanah:
"Happy New Year!" For Peter—magic handcuffs.
But only you, Aunt Jenny, could show him
how to free himself, the way you would so easily
free poor dreamy Jan from her awkwardness,
breaking the curse (her fear of ugliness)
like a fairy godmother or good witch.

Sorting through your luggage in her room,
you wave around some fringed hippie vest
you say is perfect for the Australian Outback,
explaining "It's great for chasing Kangaroos"
before, more seriously, you say you never
had the time for plastic surgery. Besides,
"How often do you see a puss like this?"

So much more alive (more Technicolor!)
in the flesh than your sad sepia portrait
Jan had found in the attic—her childhood
look-a-alike—sending her into such a panic.
But after you leave her (for the next plane
to Paris!) the resemblance will endure
when she tells boys she won't be ready
to settle down. "I won't be until I'm at least
sixty... And even then I'm not sure."

In the Seventies

America served Hot Tuna, Meat Loaf, Bread and Ambrosia with a Taste of Honey every Black Sabbath to its Bad Company: The Grateful Dead—a Blue Oyster Cult of Outlaws in Dire Straits—who would shoot The Village People in the Heart (with .38 Special Sex Pistols until they bled Deep Purple and Moody Blues), escaping in a Rush that Three Dog Night in a Led Zeppelin like an Iron Butterfly on a Journey to The Fifth Dimension where Earth, Wind & Fire was mere Canned Heat, some Cheap Trick or Kiss of an Electric Light Orchestra for its Queen who could care less about a Foreigner, some Supertramp or New York Dolls—Yes, The Clash between Chicago and Boston, Kansas or The Ohio Players, was not her Traffic, not her Rainbow to Molly Hatchet.

Michael Montlack

Mescaline BBQ

Down the street, mad (boy) scientist Seth extracted Daddy Long legs one by one with nail-bitten fingers, trying to impress my twin Michele, who shrieked loudest of all the girls while our mother, absorbed in the hum of ac and electric can opener, prepared three-bean salad.

Bored with dissection, I lingered in our yard, spying on Pam, my older sister, somehow political in her DISCO SUCKS T (knotted at the waist) with her less pretty cabinet: Donna, Amy, Margie ... of the Farrah manes who gathered round her on a sidewalk square while she swayed and ground her platform clogs, instructing Amy (SHIT HAPPENS) to ignite with a Marlboro the wavy lighter-fluid circles Pam herself had splattered in a blind spin.

When the flame looped her legs, the only screams were Michele's—distinct though houses away—as she ran from Seth's cicada shells, which she dreaded every summer, fixating on that core vanished from its casings: transparent skin vacated by its own self.

Voiceless, songlesss—even Pam's imaginary back-up singers would have sensed in her no cause for dance, every reason to burn.

"In addition to being the author of the poetry book Cool Limbo (NYQ Books, 2011), I am the editor of the Lambda Finalist essay anthology My Diva (University of Wisconsin, 2009) as well as its poetry 'sister' Divining Divas (Lethe 2012). Recently I was awarded a writer's residency in Germany, and one of my poems won the 2013 Gival Press Oscar Wilde Award. Currently I split my time between New York City and Portland, Oregon."

Patricia Schappler

I look to family and close friends as central to creating both the concrete and spiritual. These themes include birth, identity, mythical and narrative histories, intimacy, loss and gain, and the search for meaning through family. Body language, proximity, scale, surface engagement, layering and mixing of materials, all work to convey that which is felt as much as seen, desirous that my family should connect on some significant level with yours, my memories included, as if they were a part of your lives, a connected sigh from one life to another.

Seeking frameworks for understanding the complexity of relationships, I find my voice through marks made, felt values, and figurative presence. I search for beauty in the everyday, and the significance of time adding up, altering, and becoming. The narrative remains the same, connected histories in an ongoing love story.

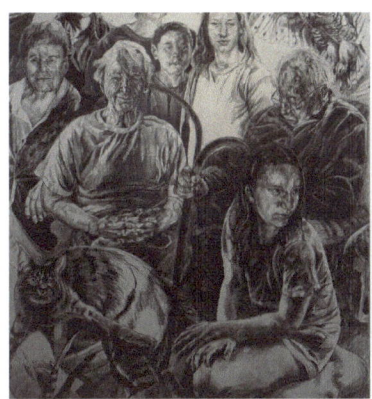 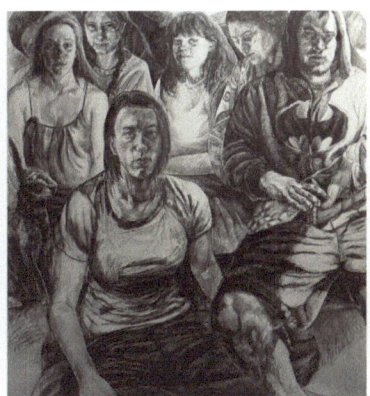 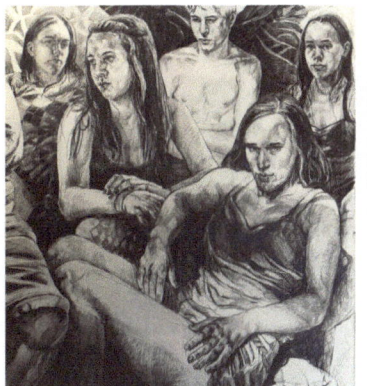 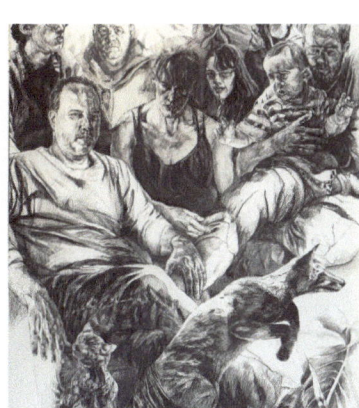

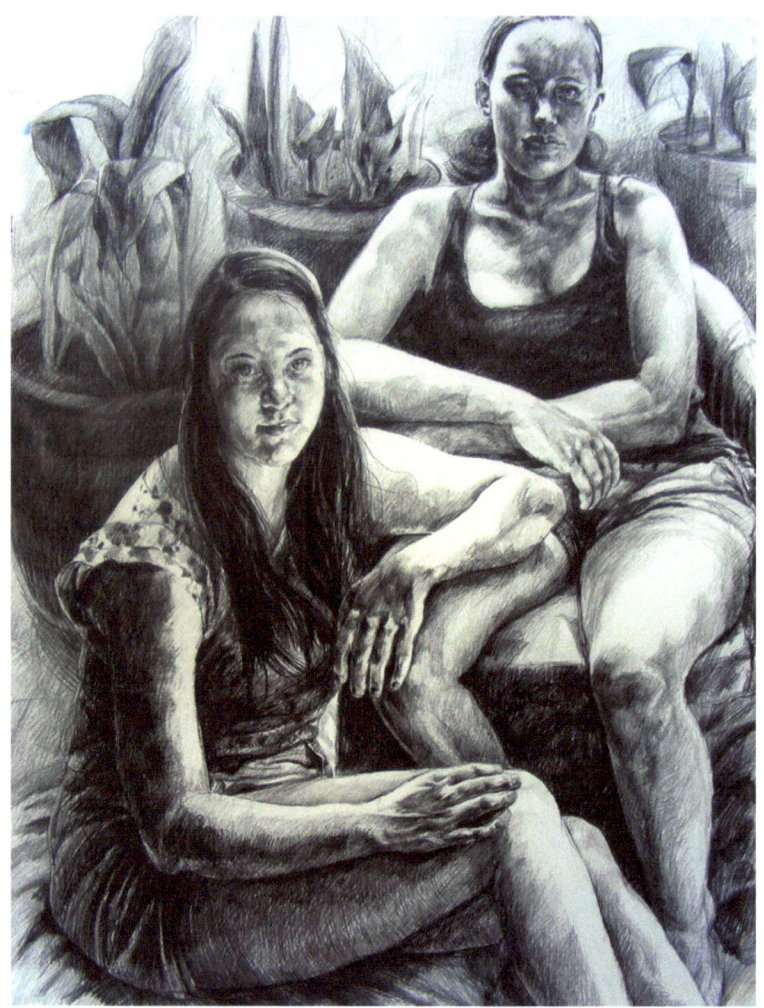

Friends
graphite and pastel
54inH x 38inW

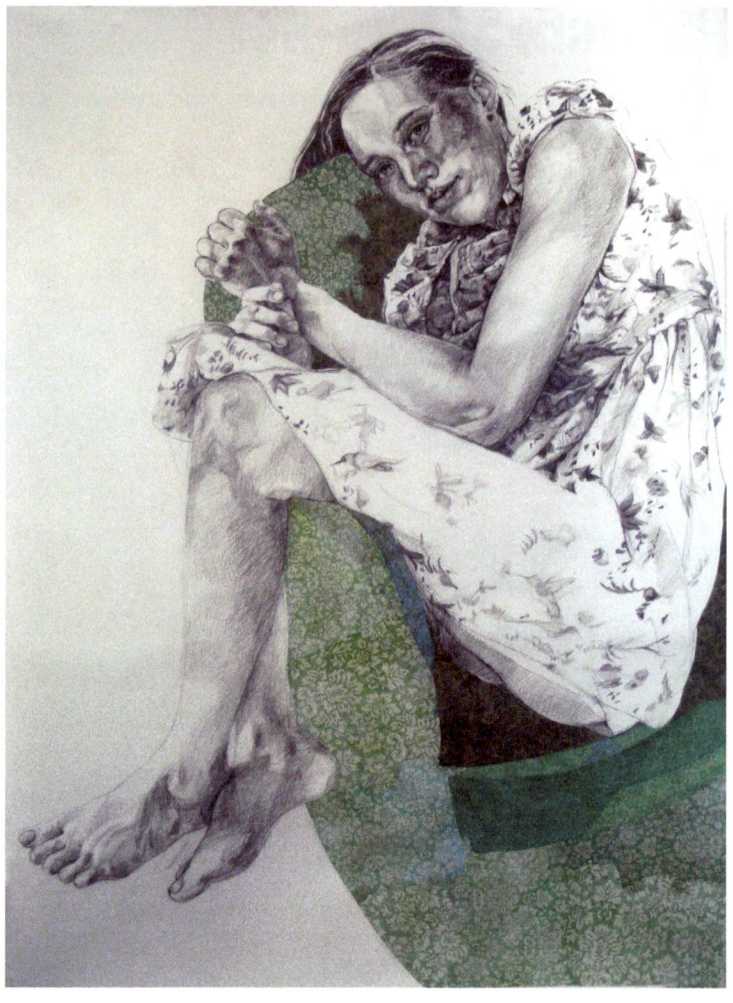

Mary
graphite and collage
57in x 38inW

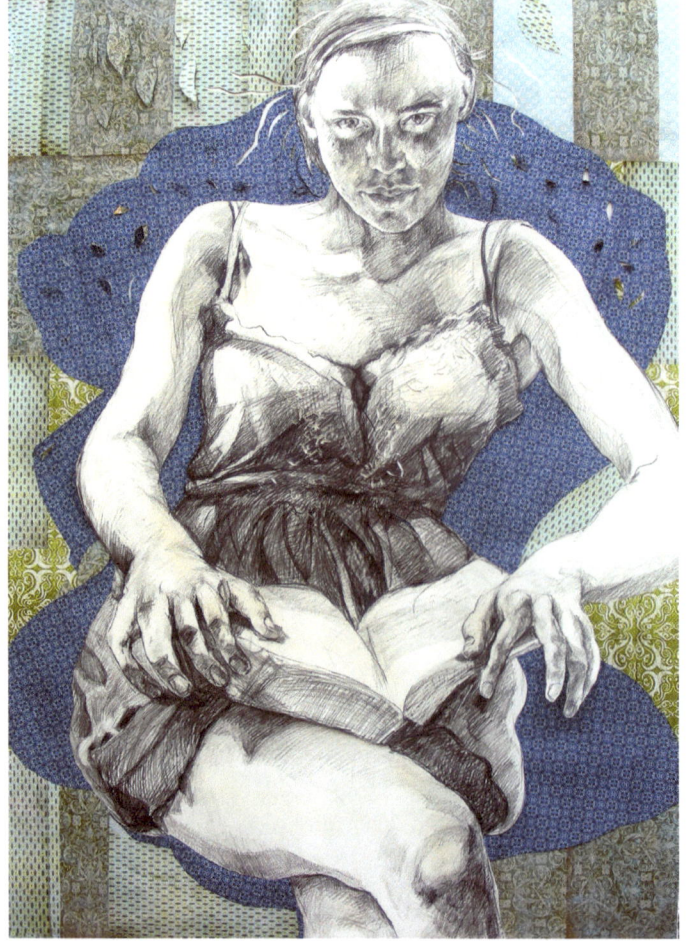

Patricia Schappler

Eve
graphite and pastel
58inH x 38inW

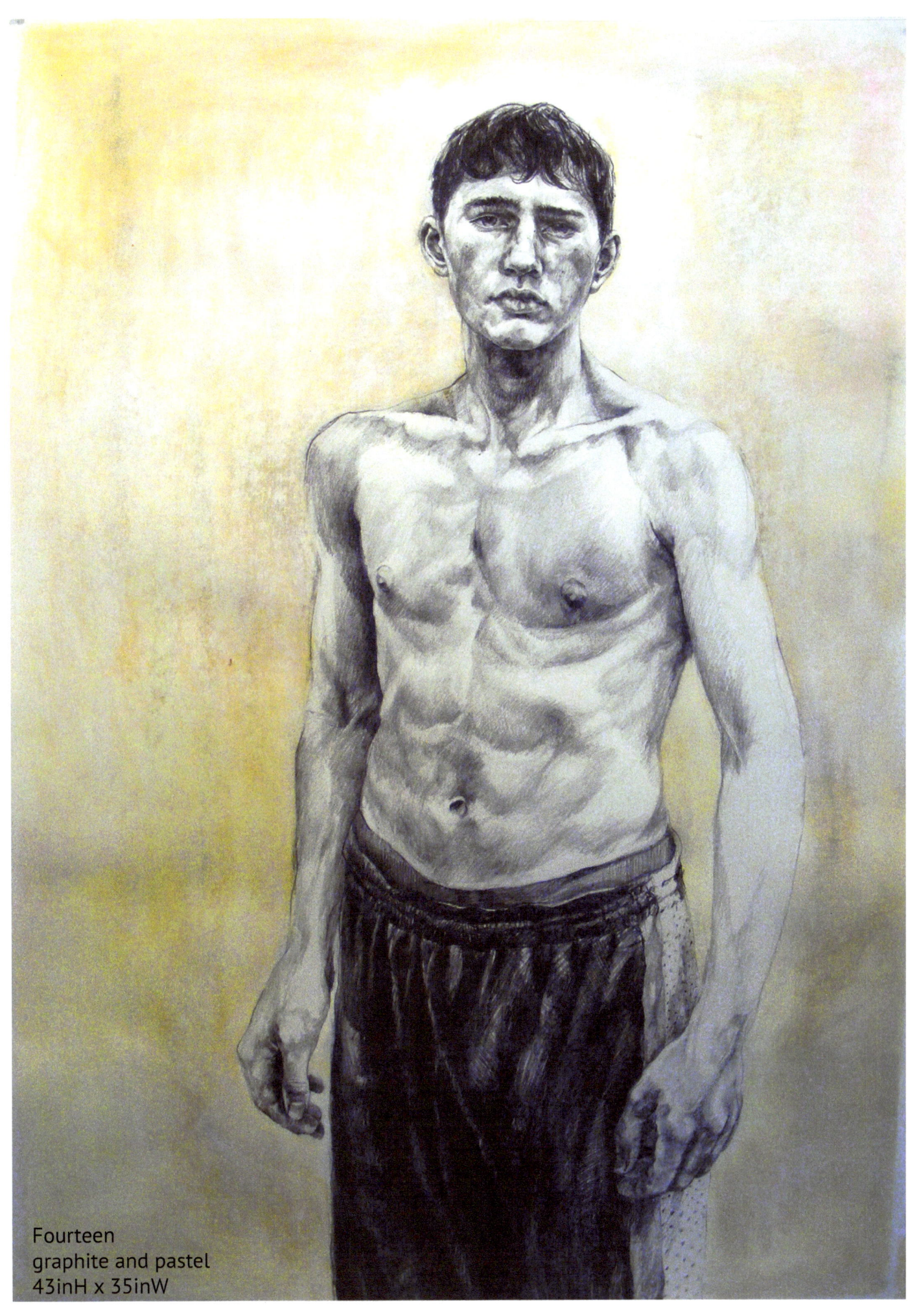

Fourteen
graphite and pastel
43inH x 35inW

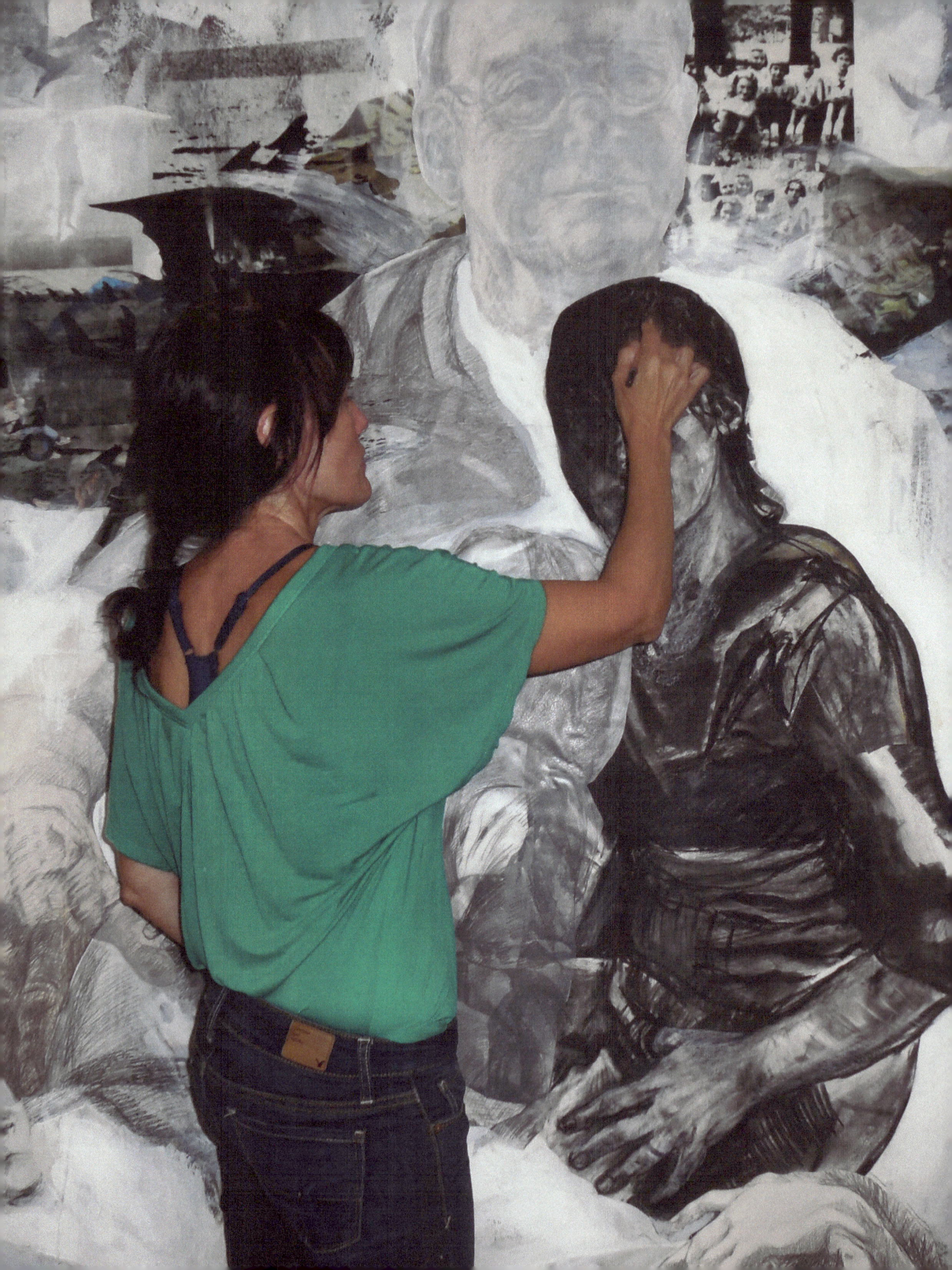

One on One
with Michelle Buchanan

Interview with Frank Bernarducci

Frank Bernarducci is director and partner of Bernarducci.Meisel.Gallery in New York. Their focus is contemporary realist art by both emerging and established artists.

You started your career as a graphic artist, and developed into a gallery owner, collector, and curator. Tell us about the transformation? Was there a turning point or moment that was significant? Or was it a gradual, more natural move?

In the early 1980s I was still living in my loft up the street from Andy Warhol's factory in Union Square. I was working as an advertising art director but in the evenings I was going to openings all over the east village. Since the loft was largely empty, I thought it might make a nice exhibition space. I invited some of my east village artist friends to be in a group show that I curated with Steve Kaplan. We had a big opening and I think it was the success of the turnout that made me want to become serious about being an art dealer. We even sold a painting, a piece by David Wojnarowicz. So naively I thought it was easy to operate a gallery. It was when I moved the operation to Soho and I was out of the advertising business completely that I really began to consider myself a dealer.

Are you still doing any graphic art?

Yes, I still enjoy designing all the artists exhibition catalogs and advertisements for the Gallery. Of course when I learned, InDesign didn't exist, everything was done by hand on a drawing board with magic markers. Fortunately Marina and the other kids know the design programs because frankly, I dislike them. They're not intuitive or user friendly at all. Like most software, it's designed by programmers, not the designers who need to use them every day.

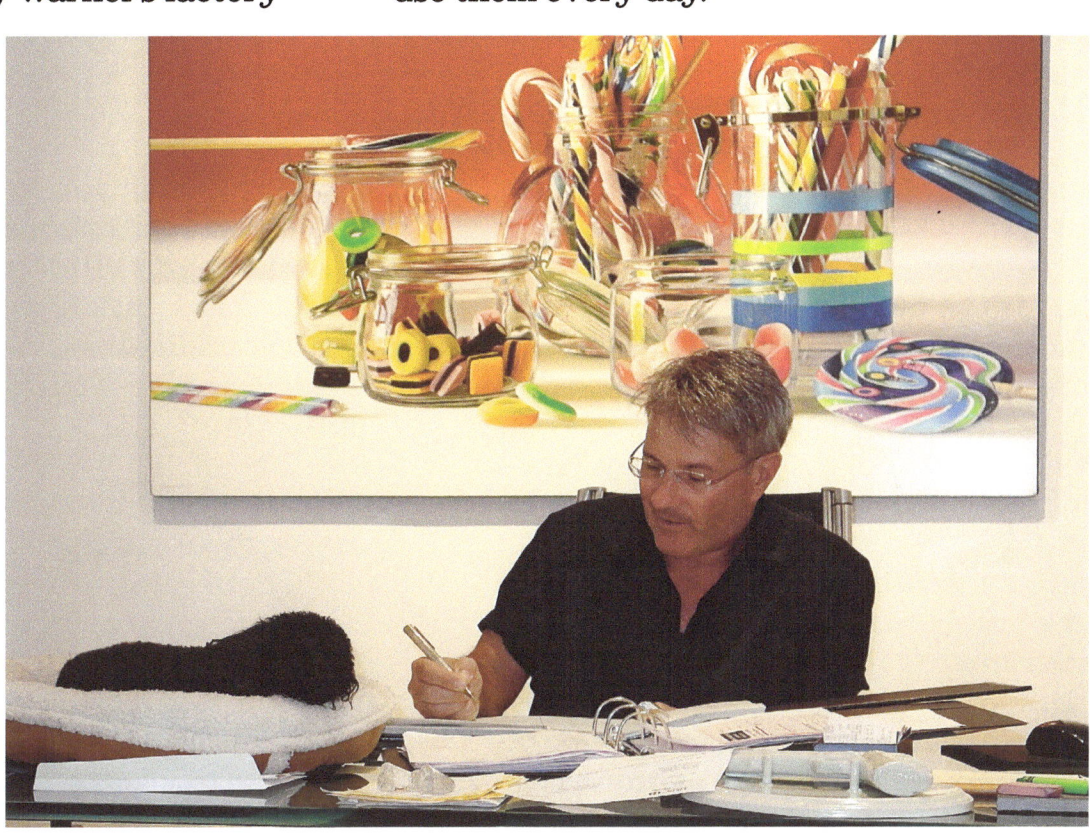

Photo ©2013 Mark Moskin/salientdesign.com

On that note: I think the profession of curator definitely fits in the category of being an artist. You might think of it as assemblage, design, even collage. In contrast, being a gallery owner and art dealer is a lot of business. I'm curious to know if curating, collecting, and finding new artists fills that creative niche for you? If yes, can you elaborate?

A curator in my view is similar to a movie producer. You are responsible for putting together a project within a realistic budget. Everyone wants to be a curator because they want to "pick the artists." That's where most curators fail miserably. If you are curating a show with your own money, you will get a much different result than if you are using some institutions money. That's why you see shows in public spaces that can take "risks." Meaning the art doesn't have to be salable. Or even attractive. So sadly, many shows wind up being aesthetically unpleasing or need a written text to figure out. One of my favorite curatorial efforts in recent memory was Shaq O'Neil's exhibition, 'Size DOES Matter.' That was a fun show. Some of the art was kind of loopy but I enjoyed it overall. Of course the Museo Thyssen-Bornemisza in Madrid has done a fantastic job with our show, 'Hyperrealism: 1967 – 2012.' But that's a historical show versus an exhibition of only 'new' art.

What is the best advice your father ever gave you either personally, or professionally?

He used to say, "Save your money." Easier said than done, I can tell you that.

I took an Aesthetics class in college and a young man in the class made this statement, "I think realism and figurative work will be dead in the next 50 years. I mean, we have photography now. My generation wants to look at work that reveals more than a reflection of something realistic. We want to stand before an artwork and see something of ourselves." Can you tell me how you would respond to that statement?

I'm sure they were saying realism will be dead in 50 years when the abstract expressionists were in their heyday. They said it again when minimalism was new. They said it again when there was such a thing as post-modernism. And yet, realist painting and figurative art is bigger than ever.

Your position as a prominent gallery owner and art dealer holds quite a bit of power in the art scene. How do you weed out authentic relationships from shallow gestures?

I'll probably just decline your friend request on Facebook. Most of my friends I've known for decades, when I was just a kid hanging out downtown with no money and nothing better to do then figure out where the next party was.

I'm not asking you to name names here. Have you ever encountered an extremely talented and skilled artist that was just a terrible person? Would that play a factor in your decision to represent them, or even purchase their work for your private collection?

I have found that often, the less talented the artist, the more difficult they can be to deal with. Some artists are so egocentric that they don't even realize how impossible they are. I've been fortunate that most of the artists we represent have become friends and are delightful to deal with so my wife and I make an effort to visit them all over the world. I would never acquire a painting by an artist I don't like. I enjoy the paintings in my collection as much as the artists who painted them.

Michelle Buchanan is a teaching artist residing in Upstate NY. When she isn't painting or teaching she likes to interview and collaborate with artists and like minded individuals.

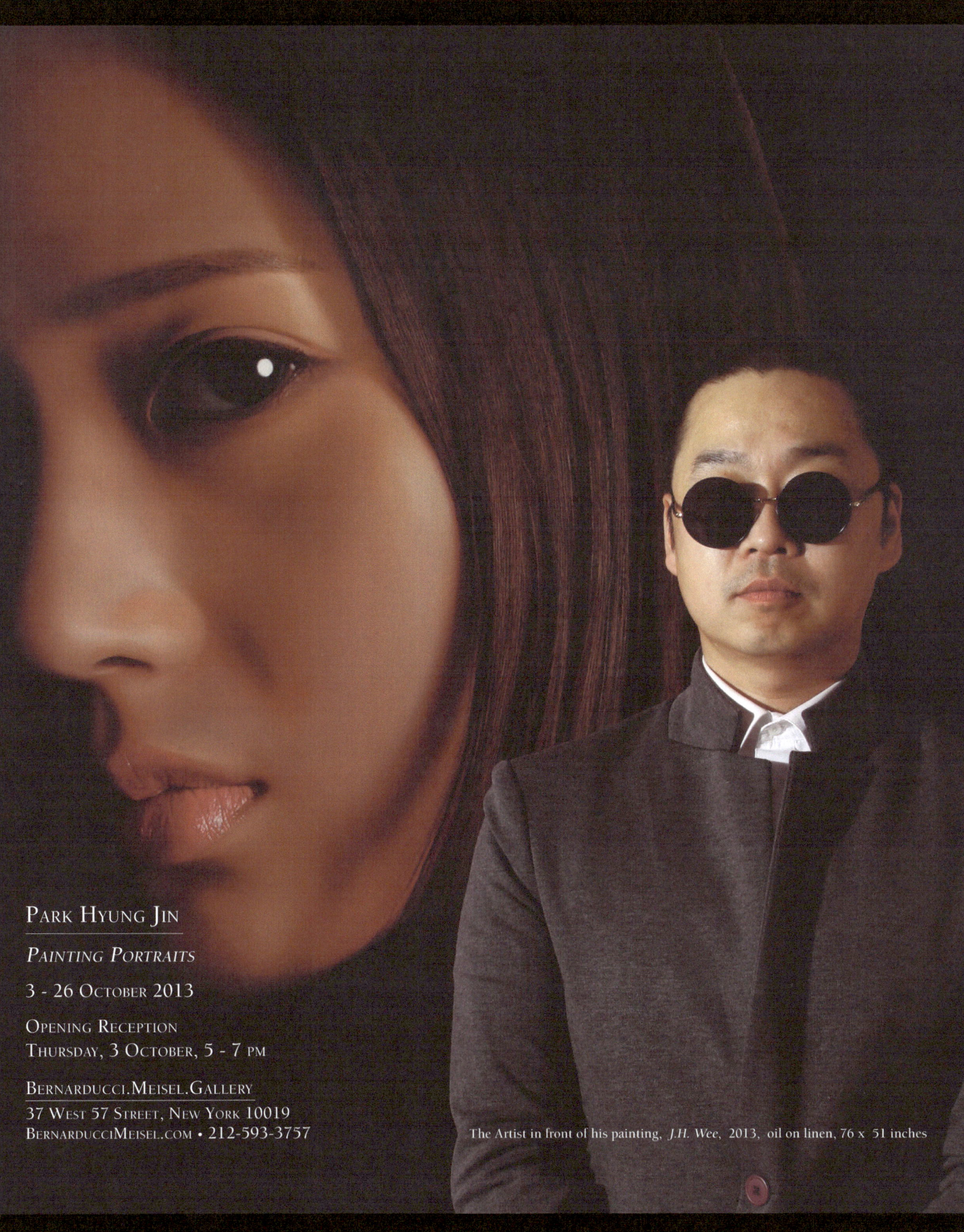

Gregory Lawless

"Lately, I've been thinking about defeat and its place in art. I wonder how responsible it is to hope for the unlikely (political and cultural change, economic progress) when description, and imaginative literature based on description, of real things suggests intractable ruin. The "State" poems included here distill a fictive polis's hardships into a few representative figures; they don't hope for the unlikely. These are little defeated things, and I apologize for that, but when I read the paper or drive around my native state of Pennsylvania, I see no other way. Now, I live in Massachusetts where my memories of Pennsylvania have grown stronger and less trustworthy. I apologize for that too, but this is poetry, and exaggeration, distortion, and faulty memory all have their place here. And I am nothing if not a distortion."

State Bug

A nightmare. Seven-
legged, the color
of nail holes in worn
wood, except
for a drop of blood
on each wing, and their twin
antennas like cherry
stems. They eat spiders
and their own. It's good luck
not to see one. If you have to
kill one, use a boot
or fire or a piece
of wood. When
you kill them, it's okay
to feel good.

Gregory Lawless

State Fair

Fried world, sun-sick
kids, an arena rock riff
spills from the Tilt O-whirl.
I'm throwing rings
at a pegboard of yellow
duck bills, trying to nab
a stuffed mallard
for my love. Girls
in denim shorts like
a water park of lust.
What would Dante do
with a blue-ribbon pig?
Grease facts: Black tattoos
giving up, dogs
lapping at the mud.
Muzzy bumblebees and where's
my EpiPen? I'm dead
drunk enough for the dark
night of rodeo that's about
to begin. The riders are strong
and broken. The animals
too big for their pen.

Gregory Lawless

State Tree

Some fruit, we never
eat it, but the deer
do, if they're desperate,
from the bottom branches
licked with thorns.
We don't know
what it looks like
from the top
but the crows do
some looking
there. They tell each other
stories there about where
the guns live and the heavy
dogs. The leaves
are steepled and eat away
from green to orange
through the fall. Some die
green and early. We don't know
how many exactly, but too
many, really.

Eric Burke

"I live in Columbus, Ohio with my family and a rich assortment of backyard birds. Though I have an MA in Classics from The Ohio State University, I have worked as a computer programmer for the past 15 years. I am a reader for the literary journal Right Hand Pointing. More of my work may be found in Thrush Poetry Journal, bluestem, qarrtsiluni, Escape Into Life, A-Minor, PANK, A cappella Zoo, Weave Magazine and A Clean, Well-Lighted Place. You may keep up with me at anomalocrinus.blogspot.com."

Self-Portrait

As a kid,
he couldn't get enough light

to go through the aperture
from the small mirror.

At forty-two,

he finally sees
rotifers in the bird bath water.

Art imitating death

for Israel Hernandez-Llach

Roberto Garcia
www.robertocarlosgarcia.tumblr.com

1.

Sst. Sst. Sssssssssssssst.
Clack clack. Clack.
Sssssssssssssst. Ssssssst.
Clack. Clack. Clackalackalack.

Freeze! Drop the cans and...Hey!!
I said freeze! Go, go! Get the...
Go, go! Radio back up! Go, go!

(pant)
 (pant)
 (pant)

Gotcha! Think it's funny?
To make us chase you?
Hey, no, no, no! Get
back here.

(kick)
 (punch)
 (kick) (punch)
I think this kid needs to relax.
I think he needs help relaxing.
Get your Taser out.

Zzzzzzzap. Zzzzzzzap.
Zzzzzzzap. Zzzzzzzap.

(high fives) (hooting) (hollering)

Hey. He's not moving.

2.

Red left your murdered heart
left the blood of every witness
Red cried Fuck the flag!
Red abandoned love
Red hated

Blue fell off veins
fell off police uniforms
Blue cried "Don't call me honor!"
Blue fled courage and crawled
back in the Krylon can you dropped

Yellow could only shine
like gold attracting greed
Yellow cried "Why death, today?"
Yellow stopped the dawn
Yellow shed tears

Green remained green
soaked up every fallen thing
Green cried Next time, always a next time.
Green changed all colors
Green waited for the rebirth

3.

Important things are invisible.
Laws, promises, civil rights,
they exist more in the ether
than on paper or in courts,
malleable and based solely
on discretion and hierarchy.

What makes an American dream?
How does one become deserving?

this, and

this and the catastrophe that is your body

and the way the men spoke whiskey and smiled above you

this and the blade of the horizon on your teeth

and how you almost blinked before they all entered your mouth

this and the faithful buzzards flight while your brother holds you down

and his friends roadhouse your legs around their hips

this afterburn in your cunt like lightning on a dead end street

this cure for living to let your brother find your pink creek in the dark

and the blooming pavement as if to say: "hold my head underwater a little longer"

this bed becoming an elegy and the dog salivating when he brings it in

your room this asphyxia this asphyxia this small death

this bathing in bleach this practicing choking

this song of decay on your tongue

this and the din of the safeword you hardly recall

Texts from the Barrio:

1

Mujer – I am sorrow smeared in God's

fattened moon

the architecture of war

they're playing my song here

can you hear it?

2

Que?

No – I'm not jealous

the sidewalks are aglitter

I am suffocating – again

3

What a sad muscle

the mouth is

the feast is starting

4

I have no secrets

"I was born and raised in rural Maine, which led me to my love of nature, trees in particular. I now live in places in and around New York City where I write poems, study trees and work in a bakery. I will read anything I can find. Poems free me."

Submission information available online.
www.poetsandartiss.com
604 Vale Street
Bloomington, IL 61701

a publication of GOSS183
publisher or artists and poets since 2000

Copyright remains with the contributors upon publication.

September 2013

www.ingramcontent.com/pod-product-compliance
Lightning Source LLC
Chambersburg PA
CBHW040743200526
45159CB00023B/1656